THE OBAMA PORTRAITS

Taína Caragol, Dorothy Moss,
Richard J. Powell, and Kim Sajet

NATIONAL PORTRAIT GALLERY
SMITHSONIAN INSTITUTION
WASHINGTON, DC

IN ASSOCIATION WITH PRINCETON UNIVERSITY PRESS
PRINCETON AND OXFORD

CONTENTS

Kim Sajet

Foreword

Shortly before the National Portrait Gallery installed the portraits of President Barack Obama and First Lady Michelle Obama, the head of our design and production team met with me to discuss installing stanchions to protect the paintings and manage the large crowds in the galleries. Never one to put barriers between people and art, I remember asking, "Don't you think we might be going a little overboard?" In a perfect example of listening to the advice of people who are smarter than you are, I am so glad my colleagues were insistent. The stanchions are still there today—two years later! Not only was I wrong, I was spectacularly wrong. So many people wanted to see the portrait of Michelle Obama—first installed at the G Street entrance of the museum—that access to the museum was heavily impeded and our visitor desk was constantly overwhelmed. Within two weeks, we had to move it to a more spacious gallery, and while I knew that this change in location would be welcome news to the museum's staff and Smithsonian security, that it made national news left me incredulous. How many times does moving a painting from one location to another *within the same building* draw so much attention?!

 That initial excitement and the public's continuing deep interest in the Obama portraits are what led to this publication. The book includes the perspectives of Dorothy Moss and Taína Caragol, the National Portrait Gallery curators who shepherded the commissions; a wonderful essay on the portraits in relation to art history by the eminent scholar and friend Rick Powell, the John Spencer Bassett Professor of Art and Art History at Duke University; and a transcript of the unveiling ceremony,

among other insightful content. With rare behind-the-scenes photographs, I am confident that this handsome book will serve as a collector's item for those who love the pictures as much as we do.

I would like to thank everyone who helped bring the portraits into being or participated in bringing this publication to fruition. From our board members and donors to the artists, curators, and writers, and, of course, the Obamas themselves, who were the inspiration for these endeavors, I am *so appreciative*. This moment, however, also affords the opportunity to thank all the many unsung professionals at the National Portrait Gallery and across the Smithsonian who made—and continue to make—the magic happen. Of particular importance are the men and women in uniform who guard the paintings seven days a week, eight hours a day, 364 days a year. As people pose for selfies and excitedly point to their favorite elements, our security officers provide a welcoming and safe atmosphere for everyone who drops by.

It is one thing to believe in the power of art to bring people together, spark critical conversations, and help change the world; and quite another to actually witness it unfolding in front of your eyes. Not over decades, but over days. Now, with this publication, published in partnership with Princeton University Press, we can relive the moments and continue the discourse about the art of leadership—literally and figuratively. To paraphrase John Quincy Adams, may this book inspire leaders to dream more, learn more, do more, and become more, both now and into the future.

Kehinde Wiley, *Barack Obama*, 2018. Oil on canvas, 84⅛ × 57⅞ in. (213.7 × 147 cm). National Portrait Gallery, Smithsonian Institution; gift of Kate Capshaw and Steven Spielberg; Judith Kern and Kent Whealy; Tommie L. Pegues and Donald A. Capoccia; Clarence, DeLoise, and Brenda Gaines; The Stoneridge Fund of Amy and Marc Meadows; Robert E. Meyerhoff and Rheda Becker; Catherine and Michael Podell; Mark and Cindy Aron; Lyndon J. Barrois and Janine Sherman Barrois; The Honorable John and Louise Bryson; Paul and Rose Carter; Bob and Jane Clark; Lisa R. Davis; Shirley Ross Davis and Family; Alan and Lois Fern; Conrad and Constance Hipkins; Sharon and John Hoffman; Daniel and Kimberly Johnson; John Legend and Chrissy Teigen; Eileen Harris Norton; Helen Hilton Raiser; Philip and Elizabeth Ryan; Roselyne Chroman Swig; Josef Vascovitz and Lisa Goodman; Michele J. Hooper and Lemuel Seabrook III; The Skylark Foundation; Cleveland and Harriette Chambliss; Anna Chavez and Eugene Eidenberg; Carla Diggs and Stephen M. Smith; Danny First; Peggy Woodford Forbes and Harry Bremond; Stephen Friedman Gallery; Sean and Mary Kelly, Sean Kelly Gallery; Jamie Lunder; Joff Masukawa and Noëlle Kennedy Masukawa; Derek McGinty and Cheryl Cooper; Robert and Jan Newman; The Raymond L. Ocampo Jr. and Sandra O. Ocampo Family Trust; Julie and Bennett Roberts; Paul Sack; Gertrude Dixon Sherman; Michael and Mary Silver; V. Joy Simmons, MD; Andrea Lavin Solow and Alan P. Solow; John Sykes; Galerie Templon; Henry L. Thaggert III

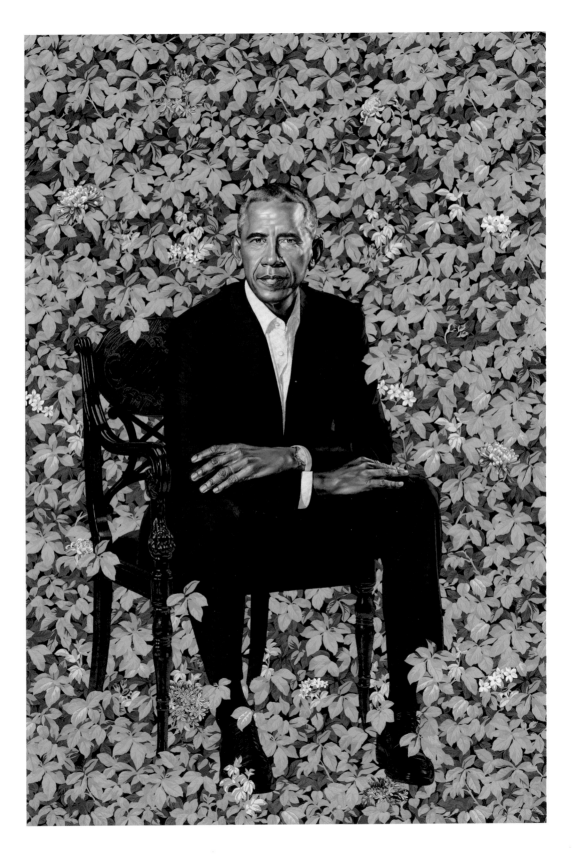

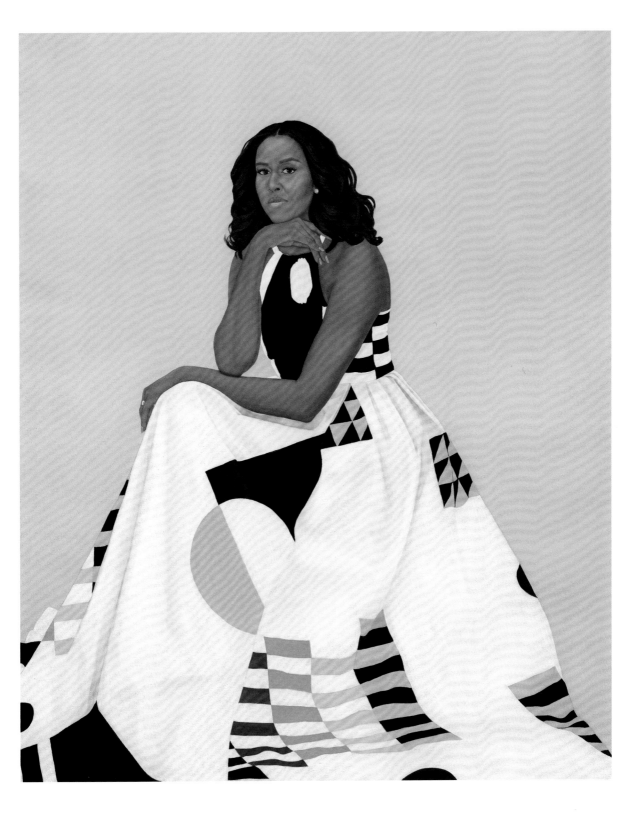

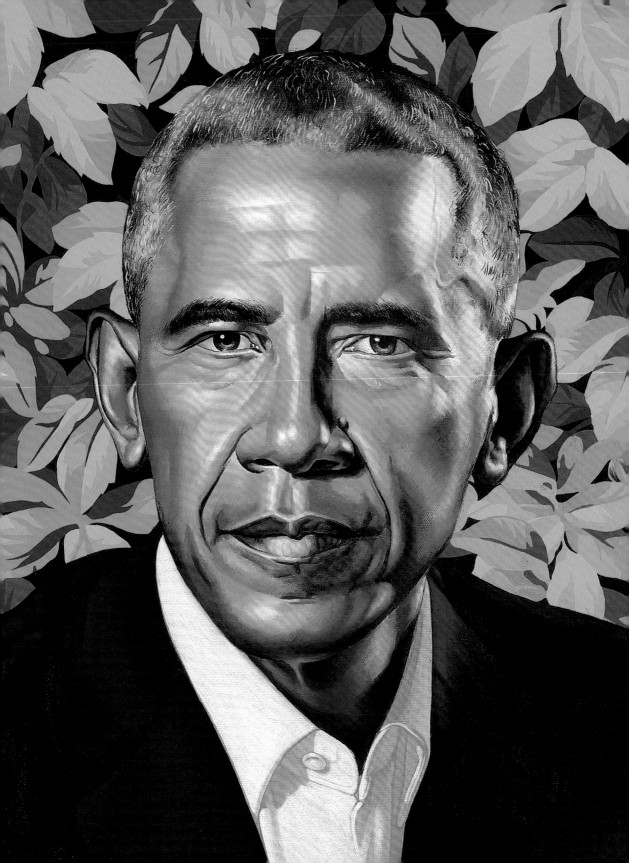

Taína Caragol

Unveiling the Unconventional
Kehinde Wiley's Portrait
of Barack Obama

On February 12, 2018, the Smithsonian's National Portrait Gallery unveiled the portraits of President Barack Obama and First Lady Michelle Obama. The White House and the museum had worked together to commission the paintings, and, in many ways, the lead-up to the ceremony had followed tradition. But this time something was different. The atmosphere was infused with the coolness of the there-present Obamas, and the event, which was made memorable with speeches from the sitters, the artists, and Smithsonian officials, erupted with applause at the first glimpse of these two highly unconventional portraits. Kehinde Wiley's portrait of the president portrays a man of extraordinary presence, sitting on an ornate chair in the midst of a lush botanical setting (p. ix). Amy Sherald's portrait presents a statuesque and contemplative first lady, posed in front of a sky-blue background (p. xi).

As a true marker of our era of connectedness, those watching the unveiling were invited to post their impressions on social media. While some criticized the paintings as being too distant from traditional presidential portraiture and debated the likeness of Sherald's depiction, the critical and public responses were overwhelmingly positive. During the first two weeks that the portraits were on view, over 4,100 press articles covering the unveiling reached an estimated 1.25 billion people worldwide.[1] Meanwhile, visitors waited in line for up to ninety minutes to see the portraits (see pp. 84–85).[2] In October 2018, the museum's calculations confirmed that the Obama portraits had produced a block-buster, increasing annual attendance from 1.1 to 2.1 million.[3] The impact

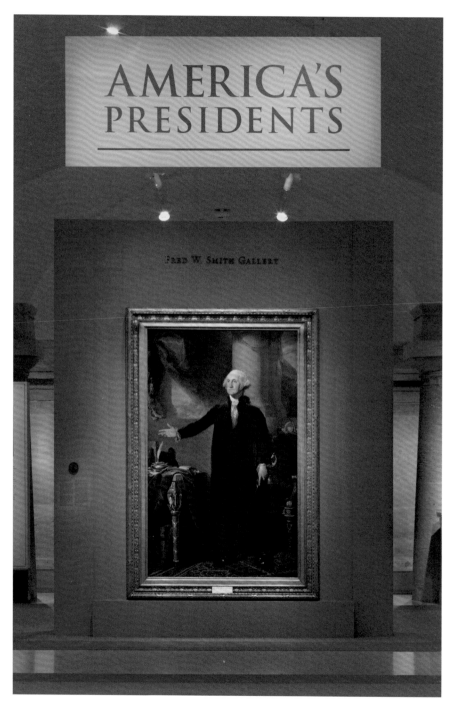

Fig. 1 Gilbert Stuart's "Lansdowne" portrait of George Washington, painted in 1796, when Washington was nearing the end of his presidency, welcomes visitors to *America's Presidents*, the National Portrait Gallery's signature exhibition.

that these paintings have had on art, on the National Portrait Gallery, and on American society is unprecedented, particularly when thinking about them as a pair.

The day after the unveiling, President Obama's portrait was installed in the museum's hallmark exhibition *America's Presidents*, bookending the chronological display that opens with Gilbert Stuart's "Lansdowne" portrait of George Washington (figs. 1–2). With the exception of a handful of paintings—including the dramatic full-body portrait of Abraham Lincoln by George Peter Alexander Healy (see p. 69); the portrait of Grover Cleveland by Swedish artist Anders Zorn, with its painterly brushstrokes and sumptuous reds (fig. 3); and the Abstract Expressionist portrait of John F. Kennedy (fig. 4) by Elaine de Kooning, with its fast, vivid green brushwork—presidential portraiture is a genre characterized by an elegant modesty that facilitates a sense of shared identity and image. Most often these portraits are realistic representations that contain a reference to the office by way of interior setting and an air of

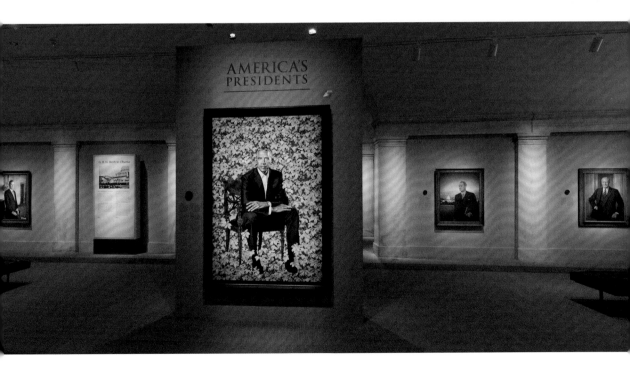

Fig. 2 Kehinde Wiley's portrait of President Barack Obama was installed in *America's Presidents* on February 13, 2018, the day after the unveiling ceremony.

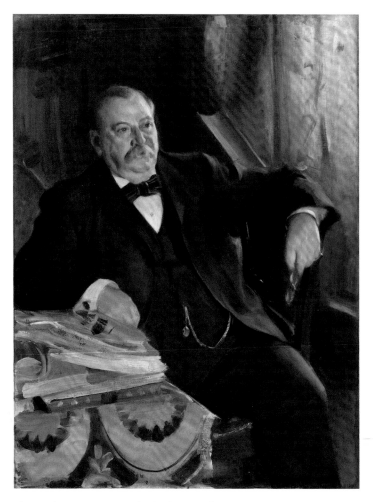

Fig. 3 Anders Zorn, *Grover Cleveland*, 1899. Oil on canvas, 47¹⁵/₁₆ × 36 in.
(121.8 × 91.4 cm). National Portrait Gallery, Smithsonian Institution; gift of the
Reverend Thomas G. Cleveland

reasonable authority. It should be noted that while walking through the
exhibition and passing one presidential countenance after another, it is
impossible to ignore that viewers are in the exclusive company of older
white men. Both Wiley's and Sherald's re-envisioning of State portrai-
ture to represent the first African American president and first lady has
captured the public imagination in a way that would not have been
possible had the artists followed a more academic template.[4]

In order to fully grasp the impact of these paintings, it is necessary
to familiarize oneself with the symbolic place they inhabit. Although
the National Portrait Gallery's large collection comprises portraits of

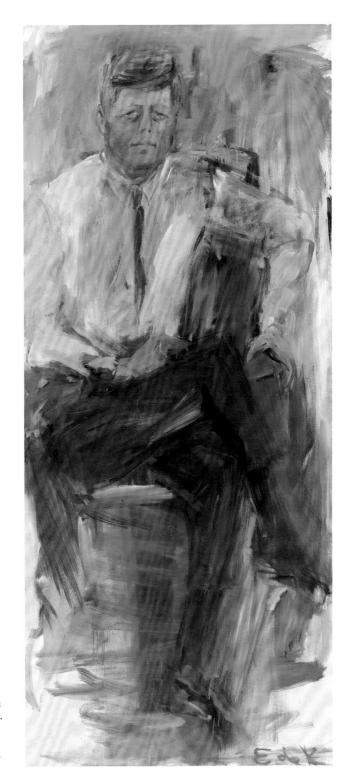

Fig. 4 Elaine de
Kooning, *John F.*
Kennedy, 1963. Oil on
canvas, 102½ × 44 in.
(260.4 × 111.8 cm).
National Portrait
Gallery, Smithsonian
Institution

Americans who have contributed to history in myriad ways, the museum is best known for its complete collection of presidential portraits—the only one of its kind outside the White House. The permanent exhibition *America's Presidents* presents oil-on-canvas portraits of each former chief executive. The medium "oil on canvas" is highly significant because it carries a sense of tradition, formality, elegance, and permanence.[5] Nevertheless, the museum also displays drawings, prints, photographs, and sculptures in its hall of presidents to offer further insight into each leader's historical context and public image.[6]

Millions of Americans travel to Washington, DC, each year, often as part of a patriotic journey, and many of those who visit the National Portrait Gallery have told us, through comment cards, that they see *America's Presidents* as symbolic of this country's democracy. One can, after all, rely on this singular collection of paintings to frame a larger story of the United States. With the addition of each new portrait, the exhibition keeps time—not only in terms of the office but also in terms of American history. And once each presidential portrait is completed, it joins the others to set the tone and expectations for those to come in the future.[7]

The Obama portraits came slowly into existence, in accordance with the National Portrait Gallery's tradition of commissioning portraits of the departing president and first lady.[8] The process took over two years from the initial conversations to the final unveiling. First, the museum's curators submitted approximately fifteen portfolios of possible artists to the White House. After months of deliberation with advisors, including the official Curator of the White House, William "Bill" G. Allman, and other fine art consultants, the Obamas created a shortlist of artists whom they interviewed in the Oval Office. They reached a decision by January 2017, and for the next ten months, their selection of Wiley and Sherald was kept secret, as it had been for past presidents. But the news leaked that October, and the *Wall Street Journal* issued a story entitled "Obamas Choose Rising Stars to Paint Their Official Portraits," instantly provoking excitement and triggering speculation as to what the portraits would look like.[9] The museum's prior presidential portrait commissions had never been so highly anticipated, and none had been widely publicized before their unveiling. The tradition was viewed as a national

Fig. 5 President Obama and artist Kehinde Wiley communicate during a sitting for the president's portrait, summer 2017.

ritual, one characterized by its detachment from the contemporary art world. President Obama's decision to grant Kehinde Wiley the opportunity to paint his portrait sent a powerful message and recast this dynamic (figs. 5–7).

The Obamas' choices were bold yet not altogether unexpected. As one of the youngest couples to inhabit the White House, they consistently projected themselves as current and trendsetting. And in a strong effort to "personalize their home," they borrowed art from museums and acquired works for the White House collection that aligned with their personal tastes.[10] Their level of interest in American art, particularly contemporary art, was unprecedented for a presidential family, and the artworks they displayed over the course of President Obama's two terms in office ranged from George Catlin's nineteenth-century scenes

Fig. 6 President Obama and Kehinde Wiley pose for a photograph during a sitting for the president's portrait, summer 2017.

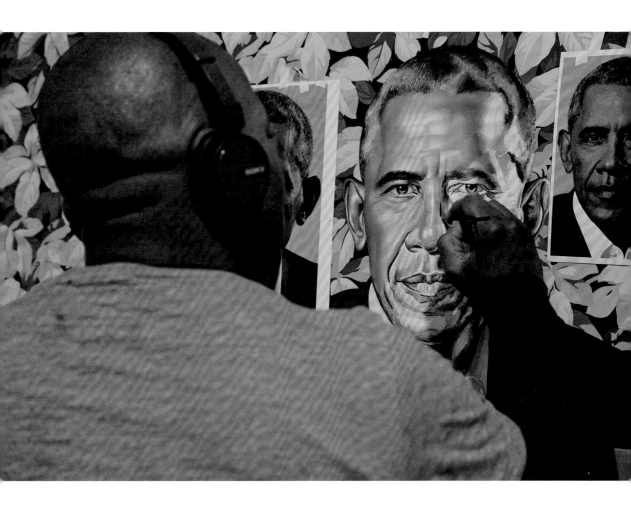

Fig. 7 Kehinde Wiley works on the portrait of President Obama, late 2017.

of Native American life to a contemporary painting by Ed Ruscha entitled *I Think I'll . . .*, which can be read as a deadpan comment on the constant decision-making process involved in the presidency (fig. 8). Another work the Obamas displayed in the White House was Glenn Ligon's *Untitled (Black Like Me #2)* (1992), the title of which is taken from the 1959 nonfiction book by John Howard Griffin, in which Griffin, a white journalist, darkens his skin in order to report on racism and injustice in the Jim Crow South (fig. 9). To make the painting, Ligon used a black paint stick to repeatedly stencil "All traces of the Griffin I had been were wiped from existence" on a white canvas until the words became illegible. Together, these artworks by Catlin, Ruscha, and Ligon represent the range of the Obamas' artistic sensibilities as well as their understanding of the power of art to transmit a multitude of messages.[11] Their choices reflect a reverence for history and the nation's cultural foundations; a non-nostalgic vision of the past; witty, self-reflexive humor; and a celebration of free and creative thinking.[12]

The Obamas are mindful of how inclusion within the canon can secure a place in history for artists, so in 2015, they brought work by Alma Thomas into the White House Collection (fig. 10). One of the most distinguished members of the Washington Color School, Thomas became the first African American woman to enter into the prestigious collection. Thomas's painting *Resurrection* was installed in the White House Family Dining Room, in dialogue with works by other masters of twentieth-century abstraction, including Josef and Anni Albers and Robert Rauschenberg. The painting was made with rhythmically applied dabs of paint shaped into concentric circles, which radiated with brilliance at the head of the dining table.

President Obama's choice of Kehinde Wiley (b. 1977) and Michelle Obama's choice of Amy Sherald (b. 1973) align with the first couple's artistic vision. The two African American artists were at very different stages in their careers when they were selected to paint the portraits of the Obamas, but both were already firmly rooted in the genre of portraiture, albeit with a contemporary outlook. In distinct ways, Wiley and Sherald are committed to making black people present in painting: in portraiture, in museums, and by extension, in the American cultural imagination. Through experimentation and by plainly subverting the

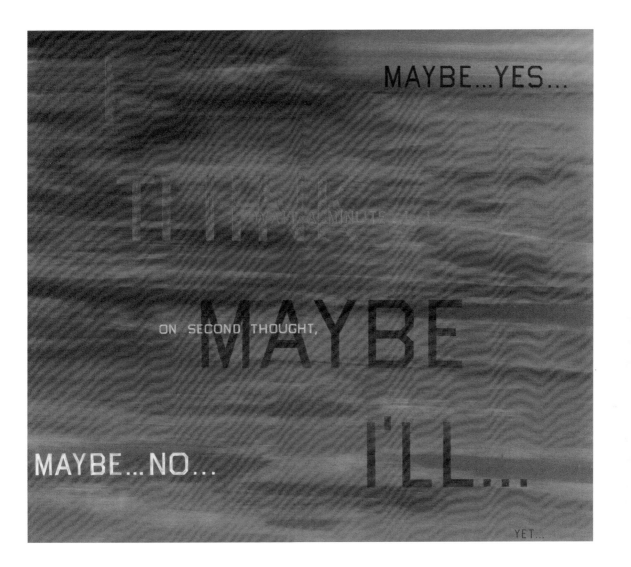

Fig. 8 Ed Ruscha, *I Think I'll...*, 1983. Oil on canvas, 53¾ × 63¾ in. (136.5 × 161.9 cm).
National Gallery of Art, Washington, DC; gift of Marcia S. Weisman, in honor of the 50th
Anniversary of the National Gallery of Art

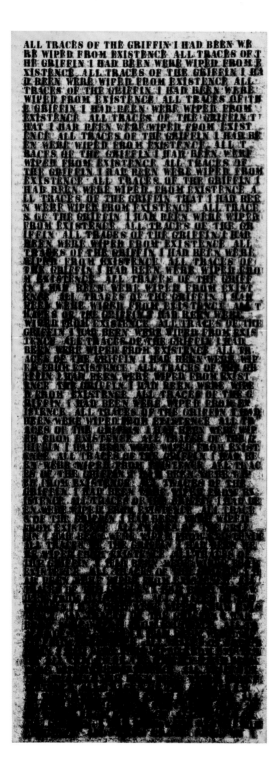

Fig. 9 Glenn Ligon, *Untitled (Black Like Me #2)*, 1992. Oil stick and gesso on canvas, 80 × 30 in. (203.2 × 76.2 cm). Hirshhorn Museum and Sculpture Garden; museum purchase, 1993

Fig. 10 *(opposite)* Alma Thomas's painting *Resurrection*, 1966, hangs in the Family Dining Room at the White House in 2016. *Resurrection*, purchased in 2015, was the first painting by an African American woman to enter into the White House Collection.

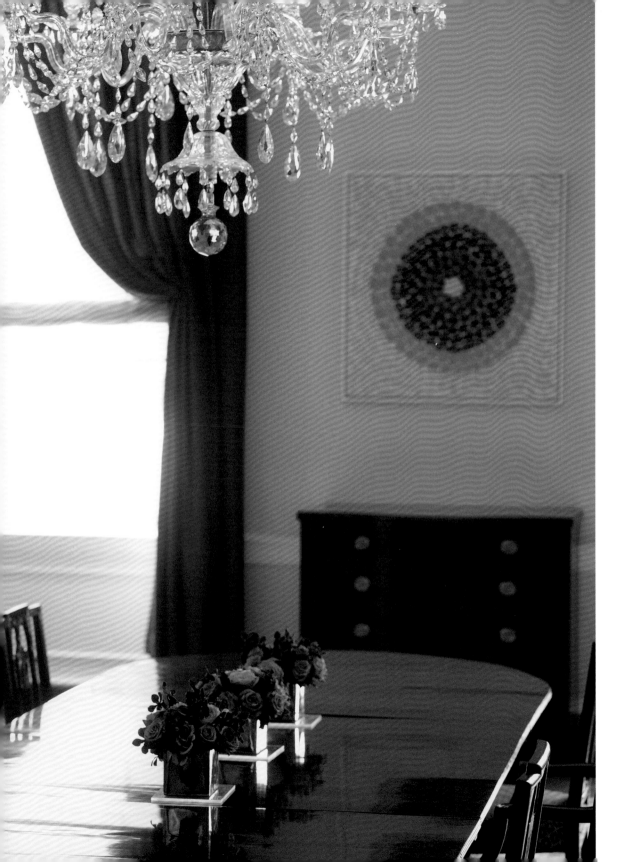

genre's conventions, both artists take on this task deliberately in order to bestow dignity and humanity on those who have for centuries been marginal or invisible in the Western canon.

As documents of both the Obamas' White House tenure and contemporary artworks that challenge tradition, these portraits cement the Obamas' reputation as powerful shapers of history who are also modern, innovative taste-makers with a brand of their own.[13] At the same time, the entry of these portraits into the museum's collection represents a significant moment in the institution's recent sustained effort to evolve longstanding ideas about the nature of American portraiture and its power through time to determine who is inscribed in this nation's history and who is erased.[14]

Wiley became an art world sensation soon after earning his MFA from Yale University's School of Art in 2001. While living in New York in his mid-twenties, he started painting larger-than-life portraits of African American men whom he came to know from everyday encounters in Harlem.[15] An artist deeply versed in Western histories of portraiture, Wiley became famous for "street-casting" his subjects and then portraying them in poses that are reminiscent of those long utilized in depictions of European aristocrats. The baggy pants, baseball caps, puffer jackets, hoodies, and other contemporary styles of dress worn by Wiley's subjects offer marked contrasts when shown on figures holding the same bearing as those of powerful European gentry.

A characteristic example is Wiley's *Napoleon Leading the Army over the Alps*, which is based on Jacques-Louis David's painting of a youthful Napoleon crossing the Alps on a rearing horse while leading his military campaign against the Austrians (fig. 11). Wiley's remaking of David's equestrian portrait replaces the European emperor with a young African American man dressed in military fatigues, a white t-shirt, a billowing cape, and Timberland boots. Instead of the rugged mountains, the figure appears to be standing against a backdrop of burgundy and gold wallpaper. The propagandist nature of the original painting by David is widely acknowledged in art history (it is known, for instance, that Bonaparte crossed the Alps on a mule a few days after his troops did). Therefore, the bombastic fantasy of the reference artwork helps Wiley's purpose. The rearing stallion, the figure with the billowing cape, and the rocks

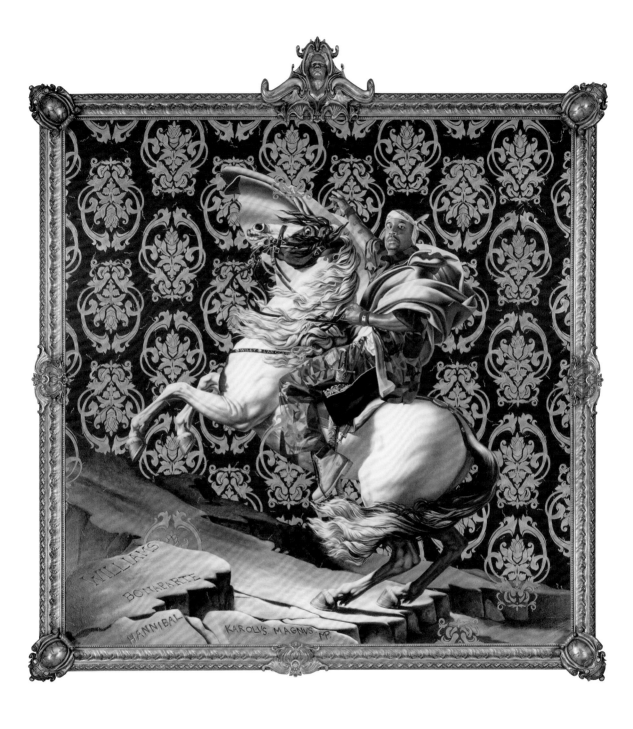

Fig. 11 Kehinde Wiley, *Napoleon Leading the Army over the Alps*, 2005. Oil on canvas, 108 × 108 in. (274.3 × 274.3 cm). Brooklyn Museum; partial gift of Suzi and Andrew Booke Cohen in memory of Ilene R. Booke and in honor of Arnold L. Lehman, Mary Smith Dorward Fund, and William K. Jacobs Jr. Fund

in the foreground are all linked directly to the lineage of military leaders who crossed the Alps: Bonaparte, Hannibal, Charlemagne, and now, "Williams," Wiley's sitter.

For more than twenty years, Wiley's oeuvre has drawn attention to the representation of race, power, and gender in historic portraiture. By the time of the presidential commission, he had earned a place in contemporary art and popular culture through his grand and ground-breaking portraiture of everyday African Americans, as well as through his paintings of icons like Michael Jackson, LL Cool J, and others from the worlds of pop and hip-hop (fig. 12). His work has evolved over the course of his career as he has expanded his range of subjects and looked to a broader range of artworks to inform his compositions. Nevertheless, Wiley continues to depict his sitters on a monumental scale, positioned against intricate, patterned backgrounds that highlight their unique, commanding poses. All of these elements are deployed to definitively assert the presence of his subjects in art history and beyond.

Over the past decade, Wiley has painted a number of women, such as those in his series *An Economy of Grace*. And more recent projects, such as his ongoing series *The World Stage*, make visible black and brown subjects from countries around the world, including Haiti, Jamaica, and Sri Lanka, drawing links between the histories of colonialism and the rise of contemporary global pop culture. These paintings are usually less grandiloquent than Wiley's earlier work. By representing men, women, and gender-fluid people from different generations and of different shapes, many of Wiley's more recent paintings depict individuals who project assertiveness and self-possession, rather than defiance. The portrait *Frederick William III, King of Prussia* (fig. 13), for instance, features a middle-aged Jamaican woman dressed in red with a heart tattoo on her arm, wearing a colorful necklace of twisting beads. With one hand on her hip and the other carrying a pink handkerchief, she looks stylish, proud, and confident. In some areas, the botanical background comes forward to entwine itself on her body, playfully engulfing and adorning her. This particular strategy of confounding the background and foreground in certain parts of the composition adds to the illusion-ism of the portrait, enlivening it through the suggestion of natural force or organic growth that refuses to be tamed, jutting forward to touch the

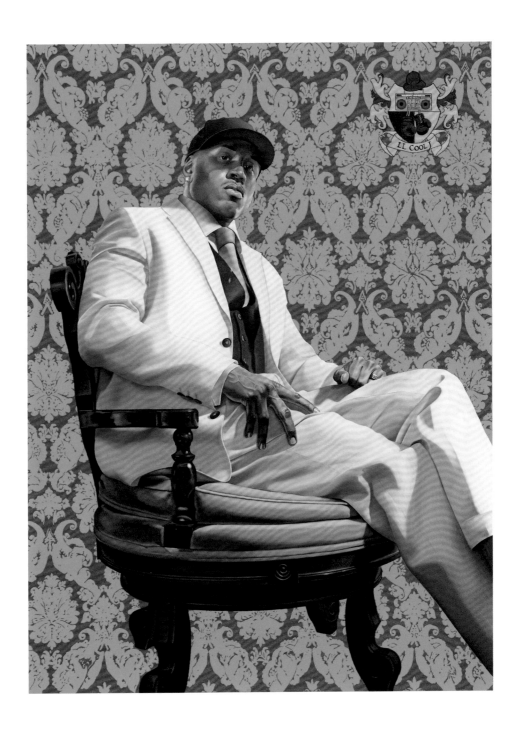

Fig. 12 Kehinde Wiley, *LL Cool J*, 2005. Oil on canvas, 96 × 72 in. (243.8 × 182.9 cm).
Collection of LL Cool J

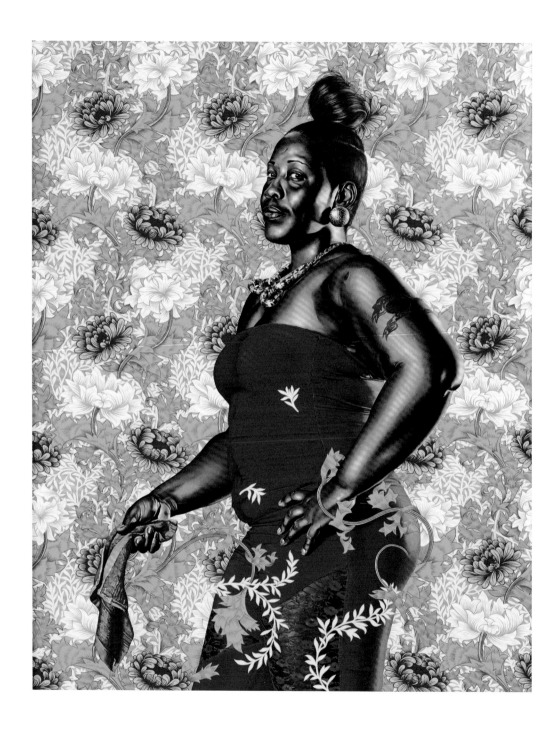

Fig. 13 Kehinde Wiley, *Frederick William III, King of Prussia*, 2013. Oil on canvas,
60 × 48 in. (152.4 × 121.9 cm). Private collection

sitter and swirl around her. This is a strategy that Wiley also adopts in President Obama's portrait, which, as an artwork, reveals the artist's shift away from purposefully bombastic male portraits to his more recent body of work.

The sensation caused by the Obama portraits can be tied to the first couple's celebrity status. Embodying so many "firsts" in US history—the first African American family in the White House; the first president of the social media age; and the first to appear to the public as down-to-earth and valuing fixtures of American culture such as sports, rap, and pop music—the Obamas were a true media phenomenon. The creation of their portraits would be another cultural moment. But high anticipation also came from knowing that the artists chosen represented a break with the more academic tradition of presidential portraiture. In a space charged with the weight of history, where the fusion of political and painterly traditions has cemented power as white and male, one could have predicted that Wiley's and Sherald's portraits would go against the grain. Today, the paintings function as an artistic intervention, one that opens up tradition so that political power can be redefined, or reimagined.

Given the artists' contrasting pictorial approaches, it is very possible that the Obamas predicted that the resulting paintings would provide an entry into their different personalities or, perhaps, capture their moods through the artists' distinct styles of painting. Together, the portraits offer a kind of yin and yang that affirms the individual traits of the first couple. Sherald's portrait of Mrs. Obama evokes a monument to a modern woman—a Madonna of our times—whereas Wiley's portrait of President Obama reveals that the artist tempered his characteristic aesthetics of grandness to represent one of the world's most powerful and recognizable men. Portraying the global leader presented Wiley with a new set of questions, ones that he had not yet faced with his standard subjects. For the portrait of the president, Wiley described having to "contend with literal power" and asking himself, "How do the rules change when the stakes are actual?"[16] In other words, for this commissioned portrait, the task at hand was fundamentally different from Wiley's usual bestowing of power on an everyday sitter through pose and symbols of power. Instead, he had to create an official State portrait that would document Obama's placement in the long line of

political figures who had led the nation. Wiley had to do this while remaining true to his artistic practice, both stylistically and conceptually. And, for the first time in history, both the artist and sitter reformulated an artistic tradition that was exclusively white.

While mindful of the history of presidential portraiture, Wiley did not employ a specific art historical template for this painting. In consultation with the president, Wiley decided to chart a new pictorial course, knowing they wanted the final painting to emphasize a language of openness and accessibility, values important to the Obama presidency.[17] Flowers symbolic of the former president's life path punctuate the greenery. The African blue lilies evoke his late father from Kenya, while the white jasmine stands for his birth and childhood in Hawai'i. The chrysanthemums, seen in orange, pink, and yellow, are the official flower of Chicago, alluding to where Obama trained as a community organizer and started his political career as a senator for the state of Illinois.[18] Although coded through ornament, this is a portrait unusually rich in biographical references. At the same time, the artist and sitter's decision to move away from conventionally impressive settings—and instead place President Obama in the midst of a botanical pattern—represents Obama's presidency as a space of blooming possibility and portrays the 44th president as one who may embody a more gentle masculinity.[19] The figure's subtle forward lean, his unbuttoned collar, and his facial expression all work together to create the effect of individual engagement between the sitter and the viewer.

It is interesting that Obama's direct gaze in the painting harkens back to the first iconic portrait of him (fig. 14). The red and blue graphic image by street artist Shepard Fairey shows Obama with an upward, outward gaze, and underneath his likeness, the word HOPE commands attention. Fairey's portrait, created independently by the artist, was adopted by the 2008 Obama presidential campaign and used for publicity.[20] It perfectly embodied the campaign's spirit, presenting Obama as a man who was at once serious and imaginative, mature and optimistic. Wiley's depiction,

Fig. 14 Shepard Fairey, *Barack Obama*, 2008. Collage of printed paper with acrylic, 69⁹⁄₁₆ × 46¼ in. (176.7 × 117.5 cm). National Portrait Gallery, Smithsonian Institution; gift of the Heather and Tony Podesta Collection, in honor of Mary K. Podesta

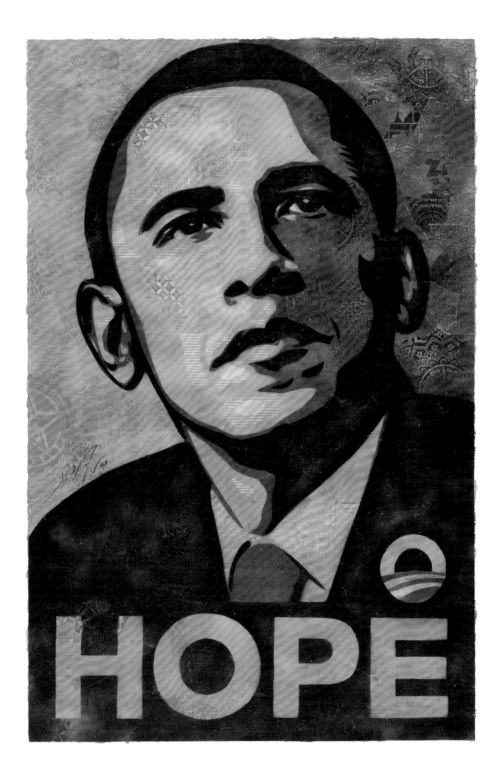

completed a decade later, conveys the matter-of-fact gravitas of a world leader who has proven himself over two terms in office and has left an indelible mark on national and global politics and culture.

Fast-forward to the unveiling, when the mystery of the portraits was replaced by their enduring mystique. In their speeches, both the sitters and the artists dwelled on the potential of visual representation to make visible and enfranchise those who have been systematically denied opportunities, recognition, and full citizenship. This is the root of the Obama portrait phenomenon. Significantly, President Barack Obama and First Lady Michelle Obama became the first African American presidential couple to have their portraits added to the museum's collection while Amy Sherald and Kehinde Wiley became the first African American artists to take on and complete the National Portrait Gallery's presidential commission. These portraits of the Obamas record a moment in which this country's executive power ceased to be the exclusive prerogative of white men. As such, these paintings are much more than a record of the sitters' roles in history. In their radical re-envisioning of State portraiture, they are bearers of possibility. They stimulate imagination and demand that each of us recognize the power we hold.

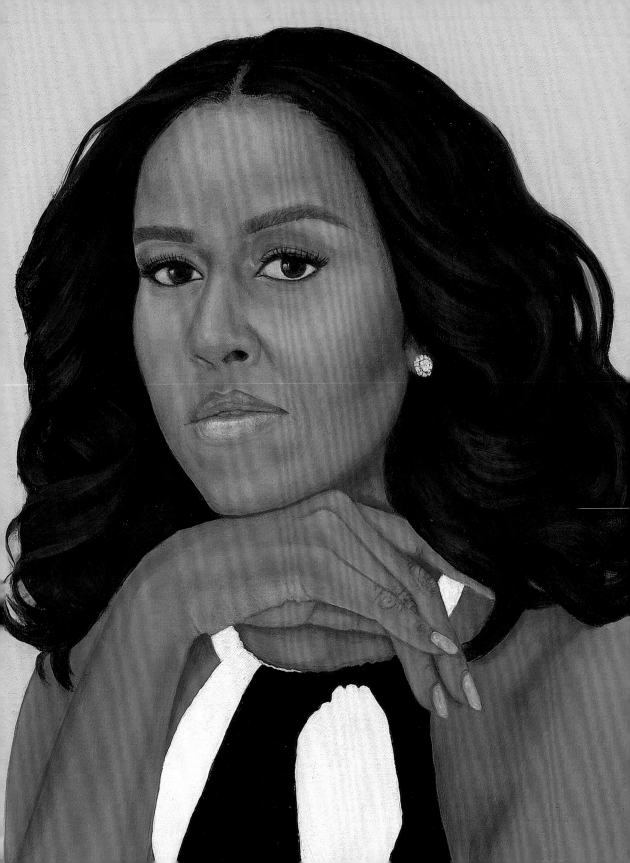

Dorothy Moss

"Radical Empathy"
Amy Sherald's Portrait
of Michelle Obama

From the moment Amy Sherald entered the Oval Office for her interview
with First Lady Michelle Obama in July 2016, the two of them began
forging a friendship. As Mrs. Obama recalled, "We started talking—and
Barack kind of faded into the woodwork. And, you know, there was an
instant connection, that kind of sister-girl connection that I had with this
woman, and that was true all the way through the process."[1]

The unveiling of Sherald's portrait of the former first lady on
February 12, 2018, will be remembered as a turning point in the history
of portraiture. When the artist and her subject pulled the velvet curtain
off the painting, their kinship and connection were revealed to the world
(fig. 1). A crowd of several hundred gathered in the courtyard of the
National Portrait Gallery, and countless others watched on live televi-
sion as the pair warmly embraced, clasped each other's hands, and
walked together across the stage to unveil the painting. In delivering
their remarks, Mrs. Obama and Sherald expressed feelings of deep
admiration and affection for one another and conveyed their shared
belief in the power of visibility and representation, especially for young
people and girls of color.

Following the event, the National Portrait Gallery was transformed
with record attendance figures, with visitors traveling to the museum
from near and far to see the portraits of the 44th president and first lady.
One of the museum's youngest visitors, Parker Curry, has even published
a book titled *Parker Looks Up: An Extraordinary Moment* (2019) about her
experience of feeling spellbound upon encountering Michelle Obama's

portrait. Soon after a photo of Parker looking at the portrait went viral, her mother, Jessica Curry, joined in several interviews to describe that moment with her daughter: "As a female and as a girl of color, it's really important that I show her people who look like her that are doing amazing things and are making history so that she knows she can do it" (fig. 2). According to Parker, coming face-to-face with the painting made her feel as though she were in the presence of "a queen," or some sort of magical amalgam of her grandmother, her mother, and herself.

Empathy most certainly emerges in front of great works of portraiture, and the cultural critic Teju Cole has eloquently described the genre's potential to forge meaningful connections:

> A portrait is an open door. It can remind us of our ethical duty to the other. "The face speaks to me, and thereby invites me to a relation," as the philosopher Emmanuel Lévinas puts it. Unlike machines, we see with sympathy. . . . Some magic happens there, a magic as old and reliable as the portraits painted on the Fayyum funerary boards 2,000 years ago. Not all portraits are created equal: To be great, they must contain presence, tension, a finely balanced amalgam of feeling and craft. "This is human," is the final meaning of a great portrait, "and I am human, and this is worth defending."[2]

As the curator who was charged with overseeing the commission of the portrait of Michelle Obama for the National Portrait Gallery's collection, it is impossible for me to separate this portrait from the context of the museum's other recent work. The artist's and sitter's messages align with our mission to advance the art of portraiture while critiquing history in order to be a more inclusive and relevant museum for future generations. Also crucial to the significance of the painting is the profound relationship between the artist and the sitter. Through these lenses, one comes to understand Michelle Obama's portrait as deeply rooted in "radical empathy," defined by writer Colum McCann as imagining oneself in the shoes of another.

Both Obama portraits are part of the National Portrait Gallery's broader vision. In recent years, exhibitions and programming have opened new spaces for critical dialogue within the museum, working to

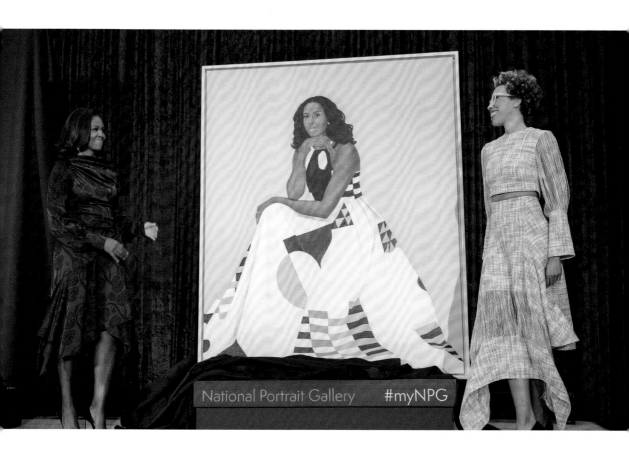

Fig. 1 Michelle Obama and Amy Sherald stand alongside the newly unveiled portrait of the former first lady at the ceremony on February 12, 2018. National Portrait Gallery, Smithsonian Institution

bring those who have been excluded from dominant historical narratives into focus. The goal is for everyone who comes through the doors of the museum to find connections to their own life experiences. This initiative offers an opportunity for the public to consider and discuss, within the walls of a federal museum (and one meaningfully situated between the White House and the Capitol), those who have been left out of history and who are often unrepresented in the nation's cultural institutions. The Obamas, who knew of this aspect of our work, routinely visited the museum with their two daughters when they lived in the White House (see p. 91). The process of having their portraits commissioned involved deliberate, careful choices they made as a family, alongside curatorial advice. These choices were in sync with the National Portrait Gallery's ongoing efforts to make absence visible—to expose what artist and MacArthur Fellow Titus Kaphar has referred to as "active absence," an artistic practice that involves pulling back the layers of history to reveal the untold stories of those who did not have access to portraiture in previous centuries, including enslaved men, women, and children, whose relationships with white men in power were significant but whose names are not written into textbooks.

This life-affirming, activist concept of portraiture was uncovered and amplified through the Obamas' engagement with a highly competitive process that began as President Obama neared the end of his second term. National Portrait Gallery curators worked closely with White House curator Bill Allman and the Obamas' art advisor, Thelma Golden, director of the Studio Museum in Harlem, to propose a selection of artists for the first couple to consider. The slate of artists put forward included traditional, academic painters, as well as those who approach portrait painting conceptually. The artists' levels of public recognition and experience also varied.

Amy Sherald was included in the group from the beginning, as one of the lesser-known artists. A few months before meeting Mrs. Obama, Sherald became the first woman and the first African American to win top prize for her portrait *Miss Everything (Unsuppressed Deliverance)* in the National Portrait Gallery's prestigious triennial Outwin Boochever Portrait Competition (fig. 3). The award brought her into the national and international spotlight for the first time, and also ensured that she

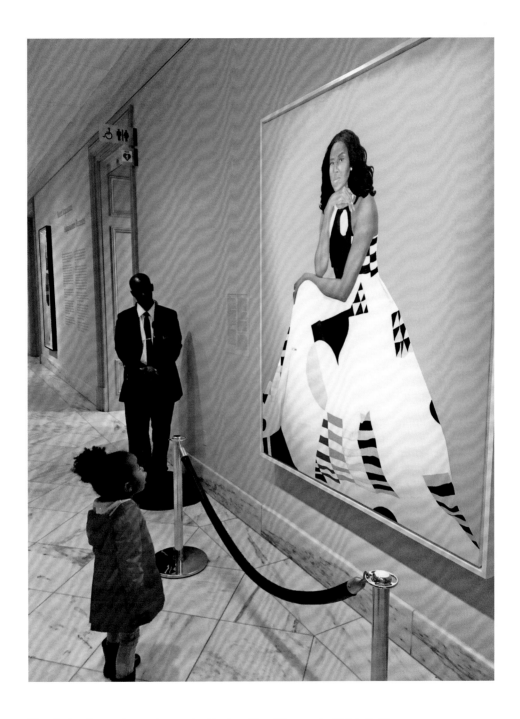

Fig. 2 Parker Curry, who was mesmerized by Amy Sherald's portrait of Michelle Obama, became the subject of a media sensation after this image was widely circulated in the weeks following the unveiling.

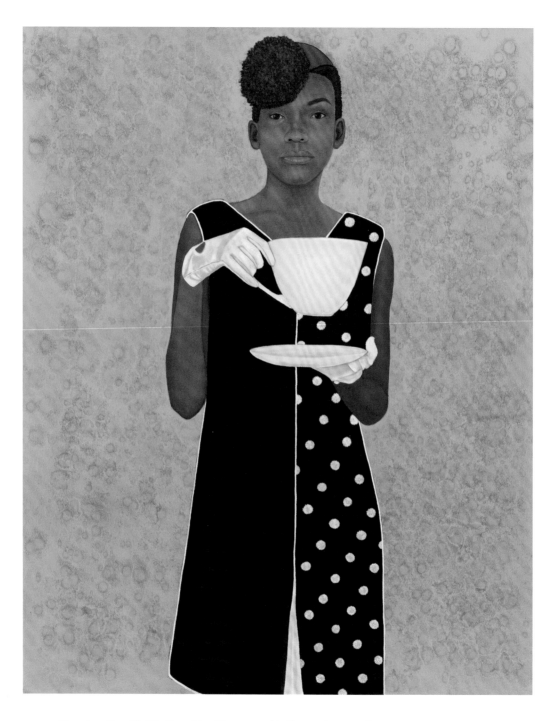

Fig. 3 Amy Sherald, *Miss Everything (Unsuppressed Deliverance)*, 2013. Oil on canvas,
54 × 43⅛ in. (137.2 × 109.5 cm). Collection of Frances and Burton Reifler

would be given the opportunity in the future to complete a portrait for the National Portrait Gallery's permanent collection.

As director of the competition, I selected Sherald for the first prize, alongside chief curator Brandon Brame Fortune and four invited jurors (curator and critic Helen Molesworth, critic Jerry Saltz, photographer Dawoud Bey, and painter John Valadez). When we saw Sherald's work, we were immediately struck by the presence of the subject in the painting. We were transfixed by the young woman's undeniable forward-looking, hopeful strength. Captivated by her self-possessed, confident expression as she gazes directly at the viewer while holding an over-sized, surreal teacup reminiscent of Lewis Carroll's *Alice in Wonderland*, we were also intrigued by the artist's use of color—especially the curious gray-scale skin tones set against vibrant blues and reds. We were drawn to the otherworldly setting created by what we later learned was the effect of Gamblin's Napthol Scarlet, an intense shade of red that Sherald places over gesso as a base for her oil-on-linen paintings, which is then layered beneath Cerulean blue mixed with ultramarine and Titanium white, and splashed with paint thinner to create a speckled effect across the surface. The figure seems to emerge from another world yet is completely of this moment. We were in unanimous agreement that this was a work of art that had something new to say.

Although the title *Miss Everything (Unsuppressed Deliverance)* suggests a fictional character, we later learned that Krystal Mack, a young woman from Baltimore, is its subject. Mack, who was selling homemade ice cream sandwiches from her bicycle when Sherald approached her, remembered the experience of sitting for Sherald and reflected on what it meant to see herself in a portrait:

> In [2013] I modeled for my friend Amy Sherald . . . The portrait is titled *Miss Everything (Unsuppressed Deliverance)*. When she was photographing me for the portrait, I asked if she had prints, and she just laughed and said no. Two years later, this painting won the 2016 Outwin Boochever [Portrait] Competition and was on display at the National Portrait Gallery in Washington, DC. The painting has traveled the country since the fall of 2016, and ironically enough, I was able to get this print from a friend who saw it at the National Portrait Gallery gift shop. Amy's official portrait

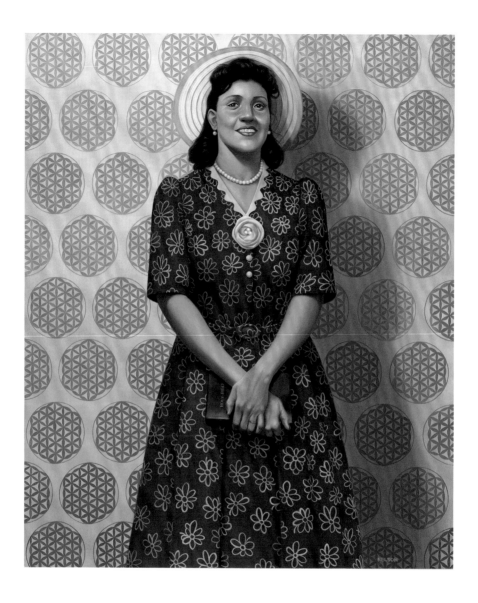

Fig. 4 Kadir Nelson, *Henrietta Lacks (HeLa): The Mother of Modern Medicine*, 2017. Oil on linen, 59½ × 49½ in. (151.1 × 125.7 cm). Collection of the Smithsonian National Portrait Gallery and National Museum of African American History and Culture; gift from Kadir Nelson and the JKBN Group, LLC

of Michelle Obama for the National Portrait Gallery debuted earlier this year. It's cool to have one degree of separation from the first lady and also to have someone I admire so much see me in such a beautiful way.[3]

Miss Everything illustrates Sherald's process remarkably well. While portraying a person, she shifts away from the individual and moves closer to creating an archetype. This evolution from a specific individual to a more generalized figure is Sherald's way of making her work universal while still insisting on the subject's blackness.

The jurors of the Outwin Boochever Portrait Competition detected echoes of Kerry James Marshall and Barkley L. Hendricks in the flatness and soulful elegance of the likeness (see p. 56) and thought it resonated with work by other contemporary figurative painters like Jordan Casteel, Sedrick Huckaby, and Kadir Nelson (fig. 4). Nonetheless, Sherald's portrait provided a fresh take on the genre of portraiture and offered a dynamic, hopeful message about the African American experience for future generations. This painting deserved first prize. The morning after the jurors made the decision to select Sherald's portrait as the winner, Helen Molesworth sent an email to the group saying, "I can't stop thinking about that insouciant girl."[4] None of us could.

And we could not stop thinking about the artist whose portrait had stopped us in our tracks. Who was Amy Sherald? I had seen her work in small shows in the Washington-Baltimore area, and Dawoud Bey had taken note of her paintings in Chicago, where she was represented by Monique Meloche Gallery. None of us, however, knew much about her. As we looked into her biography, we were stunned to learn her remarkable story, a life's journey that would speak deeply to Michelle Obama, who later commended Sherald for her perseverance: "She stayed faithful to her gifts [and] refused to give up on what she had to offer to the world."[5]

Amy Sherald grew up in a middle-class household in Columbus, Georgia (fig. 5). Her father hoped she would one day take over his dental practice, but she ultimately left the pre-med program at Clark Atlanta University (CAU) and changed her major to studio art. While at CAU, Sherald took classes at Spelman College with artist Arturo Lindsay and participated in the Spelman College International Artist-in-Residence program in Portobelo, Panama, in 1997, the same year she graduated.

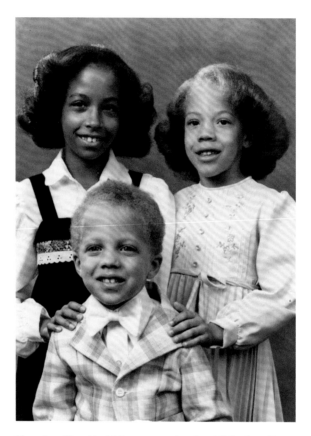

Fig. 5 Amy Sherald with her younger brother, Michael, and her
elder sister, Harriet, in 1978. Collection of Amy Sherald

Following the completion of her MFA at the Maryland Institute College of Art (2004), where she studied with Abstract Expressionist Grace Hartigan, Sherald spent time working internationally through several prestigious artist residencies. She studied with artist Odd Nerdrum through a residency in Larvik, Norway, and spent time working at the Tongxian Art Center in Beijing, China. In 2012, just as Sherald was beginning to hone her figurative painting style and establish a working rhythm, she had an emergency heart transplant. Compounding this challenge, Sherald's brother, Michael, passed away the same year. Her work in the studio was placed on an indefinite hold as she recovered and then spent time with her mother in Columbus.[6]

In 2016, Sherald was back in Baltimore, working solo in a studio through the Creative Alliance residency program. She found time to paint, whether it was in the evenings after teaching art classes for incarcerated men or in between odd jobs she took on to pay her rent. By the time I met her that year, she had slowly, methodically, and quietly built a significant body of portraits of African American individuals, many of whom she had met in her neighborhood's parks, playgrounds, or restaurants. She looked for subjects who captivated her imagination. It would sometimes take months for her to find her subjects, but she always trusted her instincts, even if it meant a slow production of work. She has discussed choosing her subjects for "their ineffable quality of existing in the past, present, and future simultaneously."[7]

Like Kehinde Wiley, whose work Sherald has admired since graduate school, she approaches portraiture and the history of representation as an activist. She often talks about her student days of searching for dignified, large-scale painted portraits of African Americans and never feeling satisfied by what she found. She finally discovered inspiration in the work of painter Bo Bartlett. A white painter, also from Columbus, Georgia, who represented himself as black in a family portrait, Bartlett made a lasting impression on Sherald. Nevertheless, it wasn't until she discovered the photographs brought together by W. E. B. Du Bois and Daniel A. P. Murray in 1899, for the *American Negro* exhibition at the 1900 Paris World's Exposition, that she was able to locate a history of dignified portraits of African American subjects. Sherald saw these

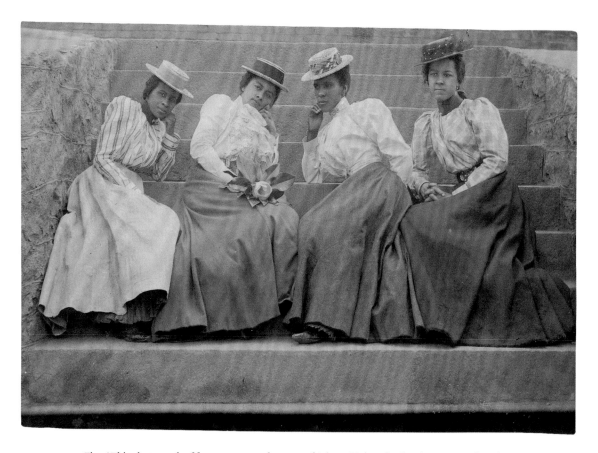

Fig. 6 This photograph of four women on the steps of Atlanta University, by Thomas E. Askew, is included in the album *Negro Life in Georgia, U.S.A.*, compiled and prepared by W. E. B. Du Bois, in 1899 or 1900. Library of Congress Prints and Photographs Division, Washington, DC

portraits in albums compiled by Du Bois titled *Types of American Negroes, Georgia, U.S.A.* and *Negro Life in Georgia, U.S.A.* at the Library of Congress, and they profoundly affected her (fig. 6). She not only paints skin in gray scale as a response to these early portrait photographs, but also as a "meditation on photography" and as a way to remind viewers of the relative absence of African Americans in the history of large-scale painted portraits. Her art brings this history into the present to point us toward the way to the future.

One portrait Sherald holds dear is a photograph of her grandmother Jewel, whom she never knew, but in whose image she sees herself (fig. 7).

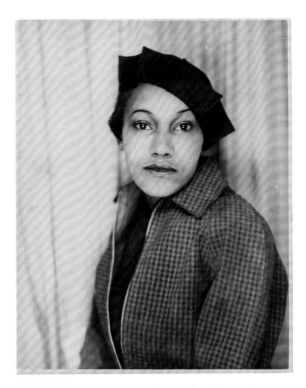

Fig. 7 Amy Sherald never met her grandmother Jewel (pictured here), but this image has nonetheless made a strong impression on the artist: "When I see that photo, I see a self-satisfied woman, I see myself," Sherald remarked. Collection of Amy Sherald

The picture conveys much of the same power of expression as *Miss Everything*. Both women appear confident and composed as they acknowledge the viewer. A similar poise and confidence radiates from Sherald, which is what attracted Michelle Obama to her when they met in person. The Obamas understood the vital importance of chemistry between artist and sitter and knew it was necessary to spend time with the top candidates before making a decision. When Sherald and the first lady met, their empathic connection was real before they spoke a word to one another. At the unveiling of the portrait, Mrs. Obama discussed that dynamic:

It wasn't lost on us how unnerving this experience was for each and every one of [the artists who interviewed], and when Amy came in, and it was her turn, I have to admit that I was intrigued. I was intrigued before she walked into the room. I had seen her work, and I was blown away by the boldness of her colors and the uniqueness of her subject matter. So I was wondering, who is this woman? And she's so cute, too! And then she walked in and she was fly and poised, and I just wanted to stare at her for a minute. She had this lightness and freshness of personality; she was hip and cool in that totally expected-unexpected kind of way. And within the first few sentences of our conversation, I knew she was the one for me.[8]

Working closely together, the two of them developed a bond that resulted in a true collaboration, based largely on the first lady's trust in Sherald. When Michelle Obama described sitting for her portrait, she said: "It's very intimate, the experience, so you really have to trust the person and feel comfortable to let yourself go. And Amy made that possible for me; we had that connection."[9] During the final sitting, this trust was palpable as the artist moved Mrs. Obama into the poses she wanted to try, positioning her shoulders slightly, adjusting the position of her fingers, tilting her head just so, brushing her hair back from her eyes, fanning her dress out around her so the soft white cotton would fall out in elegant drapes and folds to catch the sunlight. The former first lady allowed herself to be vulnerable in the process by granting Sherald the opportunity to direct the important decisions of pose, dress, and setting (fig. 8).

The soothing background color is a shade of blue that Sherald mixed using Yellow Light (Old Holland 6), King's Blue Light (Old Holland 256), and Cerulean Blue (Old Holland 39), and it situates Mrs. Obama in a celestial space (figs. 9–10). This is in contrast to President Obama's earthly backdrop in the portrait by Kehinde Wiley, which shows the president placed in front of a wall of flowers and groundcover. Neither artist knew of the other's choices, resulting in an unintentional synergy

Fig. 8 First Lady Michelle Obama poses for her portrait in a garden, in Maryland, on October 2, 2017.

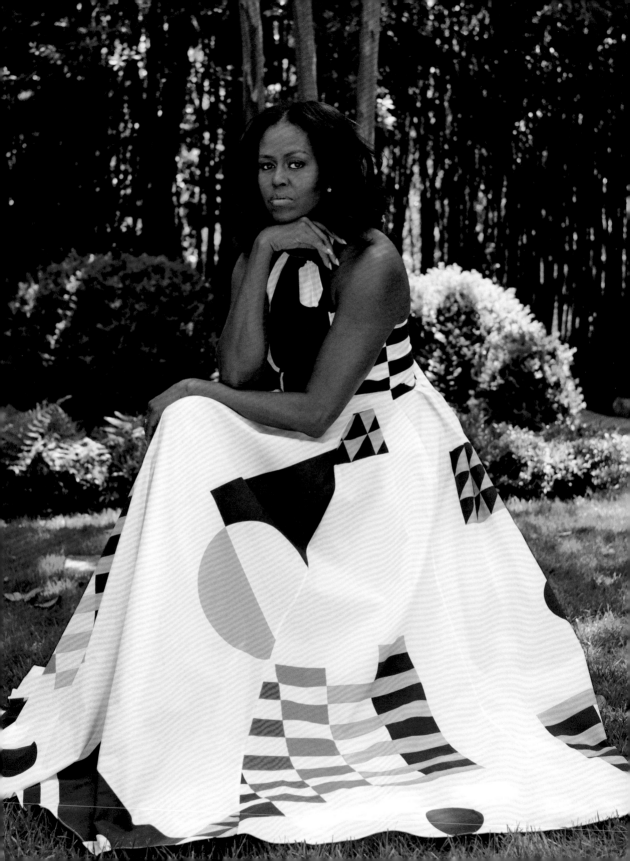

between the backdrops. The blue backdrop of Michelle Obama's portrait impresses upon the viewer a transcendent state of being. As Sherald has remarked, "My approach to portraiture is conceptual. Once my paintings are complete, the model no longer lives in that painting as themselves. I see something bigger, more symbolic. An archetype."[10] Yet even in that transformation, Sherald captured a present, engaged, and authentic view of the former first lady, one that conjures how Mrs. Obama describes herself in the epilogue of her memoir *Becoming* (2018): "I have become, by certain measures, a person of power, yet there are moments still when

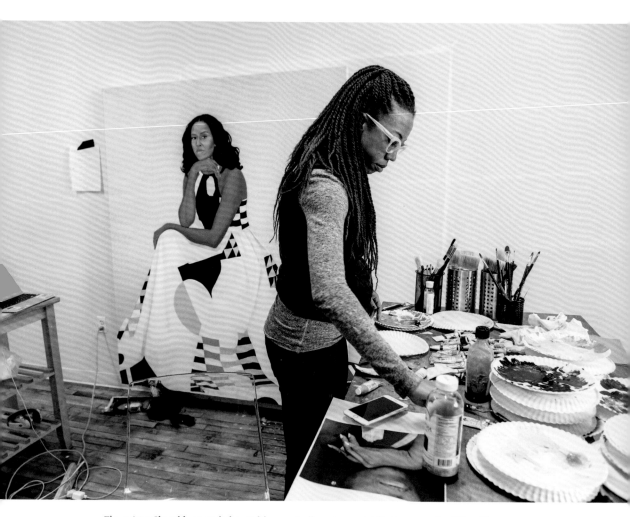

Fig. 9 Amy Sherald, set up in her Baltimore studio, mixes paint for her portrait of Mrs. Obama, late 2017.

I feel insecure or unheard."[11] Her regal, seated pose and her contemplative facial expression come together to convey this coexistence—or balance—of strength and vulnerability, of authority and humility.

The breezy white cotton dress that Sherald selected was one of several possibilities offered by Michelle Obama's stylist, Meredith Koop. Designed by Michelle Smith for the label Milly, the garment presents Mrs. Obama in clothing that appears both comfortable and fashion-forward. At the same time, the geometric patterning on the dress reminded Sherald of the African American quilt-makers of Gee's Bend, a small peninsula in

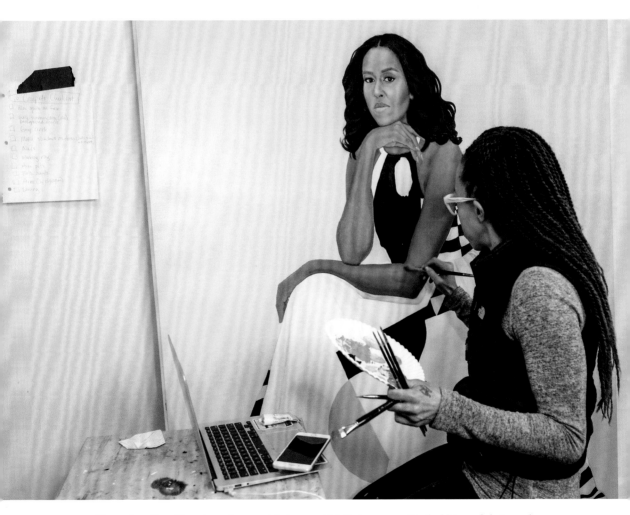

Fig. 10 Amy Sherald works on the gray skin tones, which for her connect to the history of photography and serve to elevate African Americans through portraiture, late 2017.

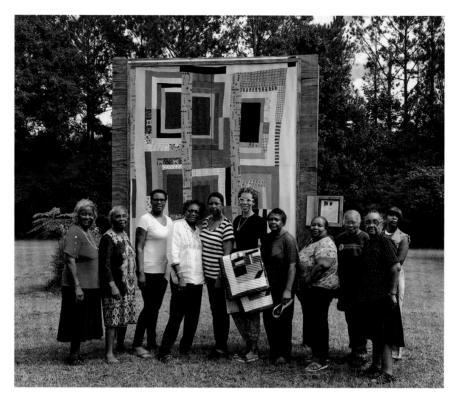

Fig. 11 Members of the Gee's Bend Quilters Collective pose with Amy Sherald (holding a quilt). Behind the group is a painted mural based on a quilt. Gee's Bend, Alabama, 2018.

Wilcox County, Alabama (fig. 11). These women, who are descendants of enslaved men and women, make quilts from discarded clothes, including blue jeans and corduroy pants. Music is part of their practice, as they are known for singing spirituals together while they stitch what Sherald describes as "quilt masterpieces."[12] The designs created through their geometric patterns and vibrant colors have inspired Sherald's art since she first encountered them in an exhibition at the Whitney Museum of American Art in 2002. "For me, it was a way to connect that painting to black history. Those shapes have that meaning for me. . . . Those shapes come from my Southern culture, quilt making, Underground Railroad maps, those kinds of things."[13]

Sherald also commented on the dress's associations with modern art, notably Piet Mondrian's *De Stijl* compositions, and said that she "didn't want the dress to just be a dress; I wanted it to have meaning as well. The pattern to me was really significant."[14] A similar type of

Fig. 12 Faith Ringgold, *Self-Portrait*, 1998. Hand-painted etching and pochoir borders on linen with quilted cotton border and nylon backing, 50⁹⁄₁₆ × 43¹⁄₁₆ in. (128.4 × 109.4 cm). National Portrait Gallery, Smithsonian Institution

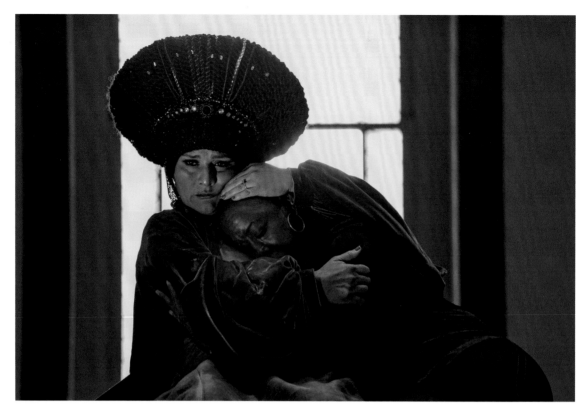

Fig. 13 IDENTIFY Performance by Wanda Raimundi-Ortiz, *Pietà*, from the series *REINAS (Queens)*, at the National Portrait Gallery, Smithsonian Institution, May 2017

geometric patterning and the black, pink, gray, and ochre colors of the dress also appear in the work of Faith Ringgold (fig. 12). Ringgold's work weaves together African American handiwork traditions from the nineteenth century to the present, including sewing, knitting, and quilt making passed on through generations of women, tracing back to their enslaved ancestors.

National Portrait Gallery staff and security officers find the experience of watching visitors interact with the portrait of Michelle Obama to be quite moving. We have seen groups come together in joyful excitement and have watched solitary visitors standing before the portrait with tears streaming down their cheeks. There are often family members huddled together for photos, looking proud. Mothers, daughters, and

grandmothers form their own intergenerational portraits in front of the painting. Groups of women friends make gestures of sisterhood and strength before it, sometimes even mimicking the famous pose of Rosie the Riveter. I was particularly stirred by the scene around the portrait when I walked into the museum with my children after participating in the March for Our Lives in March 2018. The museum was packed with crowds spilling out of the gallery in which Michelle Obama's portrait is placed, just off the corridor from where President Lincoln greeted guests for his second inaugural ball in March 1865.[15]

The *New Yorker*'s Doreen St. Félix aptly described the portrait as "shocking because Sherald has somehow conjured a vision of Michelle Obama, one of the most photographed women in history, that we have not yet seen—one free of the candid Washingtonian glamour found in photographs such as those in Amanda Lucidon's *Chasing Light: Michelle Obama Through the Lens of a White House Photographer*."[16] When I first saw the portrait in progress, I, too, responded to the artist's uncanny ability to portray a less familiar—albeit a more complex/real/genuine/empathetic—first lady. With the triangular shape of the figure asserting gravitas and with the slightly tilted head conveying compassion, Sherald had, in effect, created a contemporary Madonna.

When viewing Michelle Obama's portrait at the museum, I cannot help but think back to Wanda Raimundi-Ortiz's 2017 performance, which took place across the hall (fig. 13). A conceptual portrait, Raimundi-Ortiz's *Pietà* addresses the artist's fears as a mother of a brown-skinned son in our current culture of increased gun violence. During the performance, which was accompanied by the Howard University Choir, Raimundi-Ortiz took turns holding volunteer members of the audience. The artist expressed her intentions:

> In this latest iteration of my *REINAS(Queens)* series, which is anchored in trauma and anxiety, I . . . investigate the fear of losing a child to violence/intolerance. I find myself fearing the inherent injustices brown children will endure based on their skin, and grieve for mothers of fallen children. Inspired by Michelangelo's *Pietà*, I will create a live performance portrait for which I sit and cradle thirty-three young people of color, the same age as Jesus at the time of his execution.[17]

Raimundi-Ortiz's performance created a space for collective mourning, leading one critic to describe it as an act of "radical empathy."[18]

In a similar way, I cannot help but see the portrait of Michelle Obama as another act of radical empathy. This quality contributes to the portrait's transformative power, not only as a work of art but also as a national symbol of strength and compassion, with the power to lift those who are responsive to its underlying message of hope. The remarks Mrs. Obama made at the unveiling speak to her depth of feeling about the portrait-making process, her deep admiration for Sherald as a person of strength and character, and her commitment to the ongoing work she expected the portrait would do—work that enables visibility, connection, and hope. After telling the audience that no one in her family had ever had a portrait made and speaking about what a meaningful experience this was for her, she said:

> I'm also thinking about all of the young people, particularly girls, and girls of color—who in years ahead will come to this place, and they will look up and they will see an image of someone who looks like them, hanging on the wall of this great American Institution. . . . And I know the kind of impact that will have on their lives because I was one of those girls.[19]

It was this message of hope and inclusion that Mrs. Obama knew Sherald would deliver. After all, they shared a vision long before they even met. This was evident in 2016, when Sherald gave a gallery talk at the National Portrait Gallery following the acknowledgment of her portrait *Miss Everything*. At the end of her talk, a group of elementary- and middle-school-age African American girls came up to her, and one of them asked, "Why did you paint this portrait?" Sherald bent down slightly, looked the young girl directly in her eyes, and said, "I painted it for you. So that when you go to a museum you will see someone who looks like you on the wall." And in that looking up, the child becomes a transcendent version of herself and realizes her own potential of what she can become (fig. 14).

Fig. 14 Visitors encounter Amy Sherald's portrait of Michelle Obama at the National Portrait Gallery. (pages 48–49): Amy Sherald's painting materials

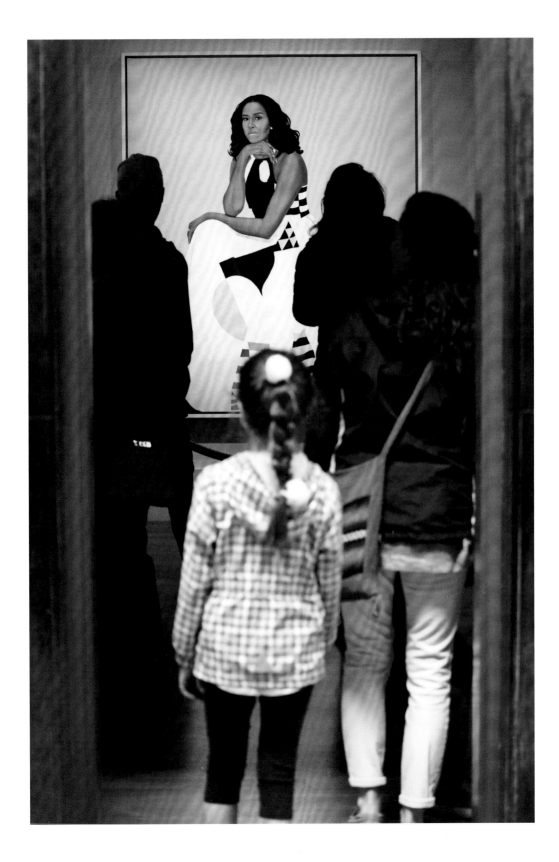

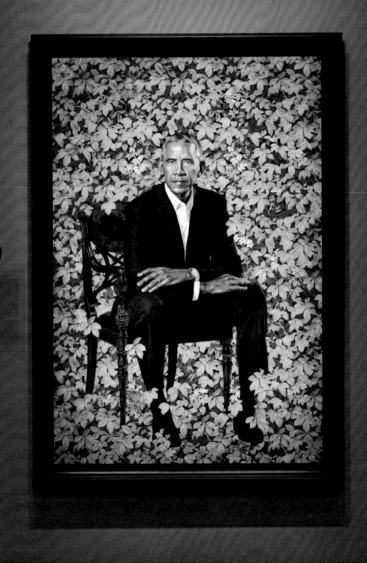

Richard J. Powell

The Obama Portraits, in Art History and Beyond

The artistic judgments that viewers impose on portraiture frequently hinge on the relative success or failure of portraitists to transmit their subject's essence. Whether or not the portraitist prevails in this endeavor is usually linked to a variety of factors, including competence in one's chosen media, the ability to successfully render physical reality (i.e., the ability to capture an accurate likeness of the sitter), or placing a subject in an appropriate environment or socio-psychological frame of reference. While skill and accuracy are quickly detectable and often placed at the forefront of many evaluations, it is the portrait's context—the artist's decision to situate the sitter within a particular cultural milieu or social setting—that, while not always recognizable to the average viewer, nonetheless emerges in the critique, and envelops the portrait within an interpretive schema and critical space that loom large in its commendation or deprecation.[1]

In thinking about the significance of Kehinde Wiley's portrait of the 44th US President Barack Obama and Amy Sherald's portrait of First Lady Michelle Obama, especially in relationship to art history broadly and the traditions of portraiture in particular, one cannot overstate the importance of each portrait's cultural context (figs. 1–2). Or, if one were

Fig. 1 Installation view showing Kehinde Wiley's portrait of President Barack Obama in the National Portrait Gallery's signature exhibition, *America's Presidents*, September 2019

to pose this aesthetic determinant as a question: in what social or cultural structure did Wiley and Sherald place their subjects, and, once received by the public, were these settings generally understood as the most apropos for the presidential and first lady portrait milieu in which these two paintings reside?

There is no shortage of news reports, art reviews, and published critiques concerning Wiley's and Sherald's creations, but noticeably absent or rarely seen in these opinions are comments that consider the two paintings in the context of: 1) other authoritative portraits, especially portraits of US presidents and first ladies; 2) the implementation of the human figure as a vehicle for an autonomous artistic statement; or 3) art history and what the eighteenth-century British painter and academician Sir Joshua Reynolds termed portraiture in the *grand style*.[2] What this analysis—by way of reading these paintings through an art historical lens—reveals is that Wiley, Sherald, and the two sitters in question have found multiple ways to both place these paintings solidly within the greater category of official portraiture and, perhaps at cross purposes, to markedly depart from that genre's expected conventions.

How Kehinde Wiley's and Amy Sherald's portraits of President Barack Obama and First Lady Michelle Obama join their predecessors in presidential and "grand manner" portraiture is fairly self-evident. They provide basic likenesses of their subjects. They defer to at least a modicum of the identificatory protocols for refined characterizations. And there are sartorial exemplars in this particular genre and other pro forma portrait practices, including the tieless presentation and halter-neck look in the Obama portraits, for what many critics view as an authorized casualness (for example, John Singer Sargent's 1907 portrait of Mrs. Isaac Newton Phelps Stokes in informal walking attire, Elaine de Kooning's 1963 portrait of President John F. Kennedy in his shirt sleeves [see p. 5], and Aaron Shikler's 1980 portrait of President Ronald Reagan in blue jeans and a work shirt).[3]

How these portraits differ from the prototypes is also quite apparent. In addition to being convincing portrayals of their subjects, both paintings

Fig. 2 Installation view showing Amy Sherald's portrait of First Lady Michelle Obama in *Recent Acquisitions* at the National Portrait Gallery, February 2018

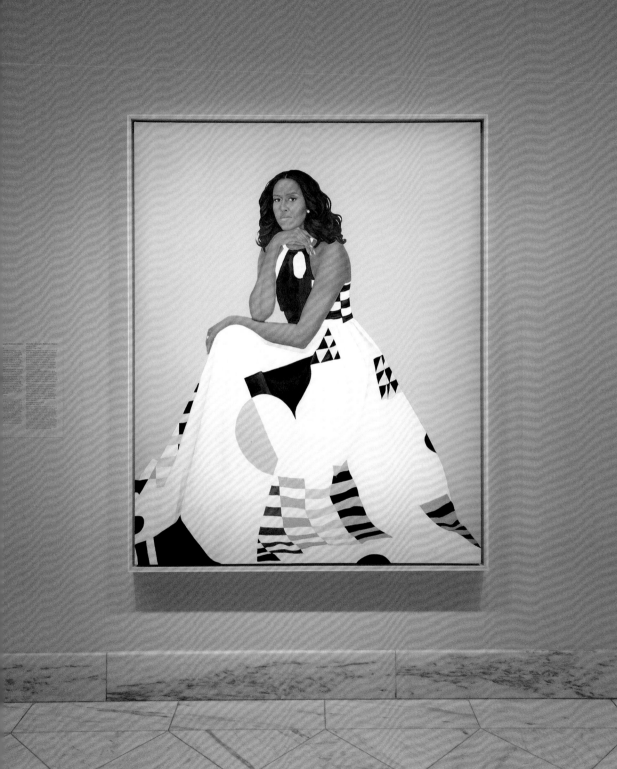

Fig. 3 Aaron Shikler, *Nancy Reagan*, 1987. Oil on canvas, 44⅛ × 24 in.
(112.1 × 61 cm). White House Collection / White House Historical
Association; gift of the White House Historical Association and the
Petrie Foundation

claim the category and, by extension, the elevated stature of contemporary art. As realistic representations of African Americans, both works stand apart from an overwhelmingly white and Eurocentric consortium of traditional portraits and other ex officio depictions. Unlike their forerunners (with the exception of the very popular, historic paintings of the first US president, George Washington), these two portraits have received unprecedented interest from the public at large, acquiring an almost devotional following since their unveiling. What these distinctions coalesce around—and, by way of emphasis, what shapes these paintings as contemporary works of art—are Wiley's and Sherald's reputations in the art world, not so much as portraitists but, rather, as cutting-edge artists who ingeniously employ the trappings of portraiture while essentially dismantling the genre's more conventional outcomes in order to convey something novel, critical, and timely.[4]

When the public sees these portraits and takes into account the aesthetic sensibilities and embodied sentience of the president and first lady, one soon realizes that Wiley and Sherald have, in effect, chronicled a cultural shift, a perceptual about-face not considerably different than, say, the geographically and culturally diverse scenes of America that appear on the antebellum-era French wallpaper in the White House's frequently photographed Diplomatic Reception Room. Images of the president and first lady posing alongside the Zuber & Cie wallpaper's assorted images of elegantly dressed black Americans, circa 1834, indicate the Obamas' cognizance of their own emblematic roles almost a century beyond those of the figures depicted in these White House decorations.[5]

A comparison of Sherald's portrait of First Lady Michelle Obama with the portraits of First Ladies Jacqueline Kennedy (1970) and Nancy Reagan (1987), both by the renowned portraitist Aaron Shikler, illustrates the difference in Sherald's concept of a formal, officially commissioned depiction of the first lady (fig. 3). Unlike Shikler's head-to-toe representations of Kennedy and Reagan—enveloped in dramatic lighting and wearing resplendent, classically inspired evening gowns—Sherald places Michelle Obama in the artist's characteristic mid-range format and in an all-over luminescence that showcases her subject with grisaille skin coloring and distinctive, multi-patterned clothing.[6] Sherald's fidelity to this approach—allied with analogous visual strategies by artistic forebears

Fig. 4 Barkley L. Hendricks, *Tequila*, 1978. Oil and acrylic on linen, 60¾ × 50¼ in. (154.3 × 127.6 cm).
Collection of the Butler Institute for American Art, Youngstown, Ohio

and contemporaries Barkley L. Hendricks, Kerry James Marshall, and Wiley, each having reimagined the black figure in the wake of studio portrait photography—found an unexpected enthusiast in First Lady Michelle Obama, whose personal input into this portrait augments Sherald's creative oversight.[7]

Sherald's portrait of Michelle Obama and its location within a youth-oriented, non-elitist, African American representational purview link this image to a significant body of black portraiture that, beginning with Hendricks's circa 1970s paintings of flamboyant and politically self-conscious "everyday people," has come to define the post–civil rights era black persona (fig. 4).[8] Whether self-confident fashion trendsetters or class- and caste-adverse social outliers, Hendricks's subjects offered an alternative to a more conservative and often corporate African American image: a brash and breezy strain of black identity that Sherald, too, artistically privileges.[9] Although certainly not as bohemian and insouciant as the women and men in Sherald's other figure paintings, the Michelle Obama portrait possesses a similar informality and ease that, colored by an appreciable self-possession, puts the first lady's portrait on par with a group of cool, fin de siècle African American portrayals in art and other visual representations.

Portrait studies more or less acknowledge not only the looming presence and power that many sitters have in the practice of portraiture but the risk these sitters often assume as they relinquish some of their control to the artist commissioned to portray them. Conversely, portraitists often find themselves at a diplomatic impasse as they execute their commissions, feeling the need to balance the expectations to portray their sitters in a flattering light along with the desire and artistic impulse to make a work of art that goes beyond a routine representation.[10] Sherald and First Lady Michelle Obama seem to have successfully overcome the anxieties and dilemmas that portraitists and sitters face as they enter into the portrait contract, their encounter possibly echoing the visible rapport and understanding that the painter Hendricks and his black subjects had with one another. Hendricks's *Tequila,* a portrait of a confident young woman wearing a sporty ensemble and a good-natured expression, may be four decades removed from Sherald's portrait (not to mention separated in terms of the social standing and level of celebrity

Figs. 5 and 6 Michelle Obama and Amy Sherald during a sitting for the former first lady's portrait, October 2, 2017

of the subject), but the two portraits nevertheless exist in a comparable, emotionally affable ambience, and in the esprit de corps of an artistically beguiling yet permeable realism.[11]

The first lady wearing a floor-length stretch cotton poplin halter dress—or "Milly Gown" that, according to its designer Michelle Smith, "could [be worn] in everyday life, as well as in this iconic portrait"—is evidence of her portrait's departure from the archetypes in the "First Ladies" portrait genre (figs. 5–6).[12] Evocative of the black-and-white photographs of women wearing ground-draped, vibrant dresses by the mid-twentieth-century Malian studio photographer Seydou Keïta (fig. 7), Obama's resolutely modern, geometric print dress and Sherald's clothing-focused composition aesthetically shared Keïta's starting point for stylishness and singularity in the African diaspora.[13] Allowing their dresses to create an optical dynamism that, in concert with the sitters, initiates a visual repartee resulting in artistic considerations well beyond portraiture, Keïta's *Untitled* and Sherald's portrait of First Lady Michelle Obama discreetly exit the doctrinal portrait category and, almost imperceptibly, enter the unrestricted orbit of modern and contemporary art.

A similar portrait-to-idealized-statement transpired more than one hundred and sixty years earlier when the French history painter Jean-Auguste-Dominique Ingres painted *Madame Moitessier*, whose opulent Second Empire surroundings and meticulously embroidered silk ball gown formed a kind of internal scaffolding and complementary, two-dimensional framework around this elegant woman (fig. 8). Openly contemptuous of portraiture, Ingres nevertheless painted many individual simulacra (most notably *Madame Moitessier*), rationalizing his work in this vein as an extension of his more serious work as a chronicler via painting, and whose responsibility for depicting a likeness was superseded by a higher calling; that of plotting a creative pathway between "nature" and "the ideal."[14] Sherald negotiated a comparable, albeit postmodern course in her Obama portrait, placing her signature heather-gray adaptations of the first lady's complexion at the center of a chromatically pure, minimalist, and hard-edge application of oil pigments on canvas. Sherald's incised and stylized approach to painting brings to mind the keen observations about an embodied abstraction made by novelist Ralph Ellison's unnamed protagonist in *Invisible Man* (1952) as

Fig. 7 Seydou Keïta, *Untitled*, 1948–54. Gelatin silver print, 23½ × 19½ in. (59.7 × 49.5 cm).
Courtesy CAAC—The Pigozzi Collection, Geneva, and Danziger Gallery, New York

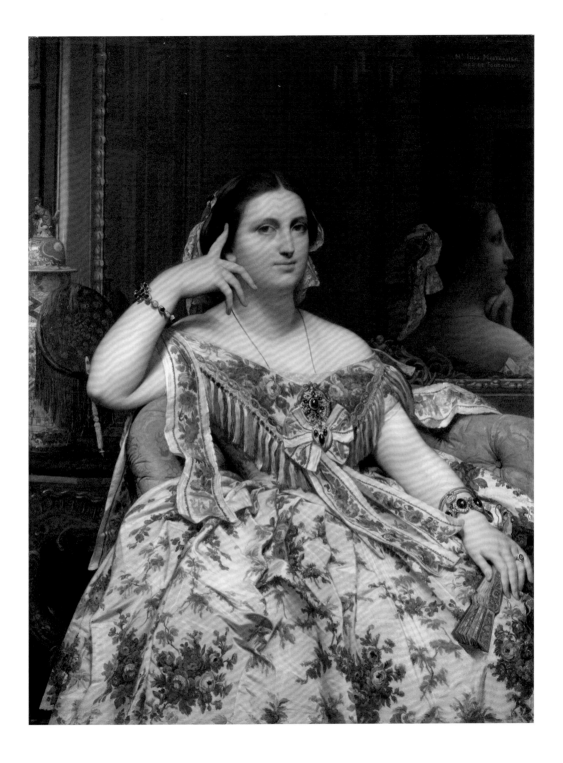

Fig. 8 Jean-Auguste-Dominique Ingres, *Madame Moitessier*, 1856. Oil on canvas, 47 × 36¼ in. (120 × 92.1 cm). The National Gallery, London

he espied a group of zoot suit–wearing black youth in a New York subway station. "What about those fellows waiting still and silent there on the platform, so still and silent that they clash with the crowd in their very immobility; standing noisy in their very silence. . . ." "What had one of my teachers said of me?" *Invisible Man*'s main character further mused in relation to these self-abstracting youth, "'You're like one of these African sculptures, distorted in the interest of a design.'" "Well, what design and whose?" was his rejoinder, a query one might also pose to Sherald as pertaining to her designs via the art of portraiture.[15]

Sherald's overtures to abstraction in her portrait of Michelle Obama—made emphatic with its stark, light-blue background and reinforced by the boldly designed, principally black-on-white patterned floor-length dress—provide an interpretative window into this portrait's priorities: viewpoints concerned with the sitter's subjectivity, display, and, paradoxically, that which in portraiture is understood as withheld or invisible. The conundrum of modern portraiture frequently revolves around its non-mimetic, abstract leanings (and the related, part-formal, part-conceptual "mystery factor"), and several of the most famous works in this category—James Abbott McNeill Whistler's *Arrangement in Grey and Black No. 1* (1871), Pablo Picasso's *Gertrude Stein* (1905–6), Gustav Klimt's *Adele Bloch-Bauer I* (1907), and Frida Kahlo's *Las dos Fridas* (fig. 9), to name just a few—unapologetically stand waist-high in these enigmatic waters. That women overwhelmingly become art history's principal characters in these exercises in opacity is perhaps not surprising, but, as seen for example in Kahlo's double self-portrait and Sherald's portrait of Michelle Obama, the implicit contract between women artists and their female subjects puts a different spin on a sitter's deep-rooted mystique and an abstraction-powered, calculated incomprehensibility (or what art historian Linda Nochlin described as "cutting into the fabric of representation by refusing any kind of simple 'mirroring' of female subjects").[16]

Like Kahlo's self-styled surrealism and role play via gendered masquerades in *Las dos Fridas,* the early twentieth-century Brazilian modernist Tarsila do Amaral employed both fashion and cubist painting techniques in her *Autorretrato (Le Manteau Rouge)* to create a screen rather than offer viewers unmediated access to her body (fig. 10).

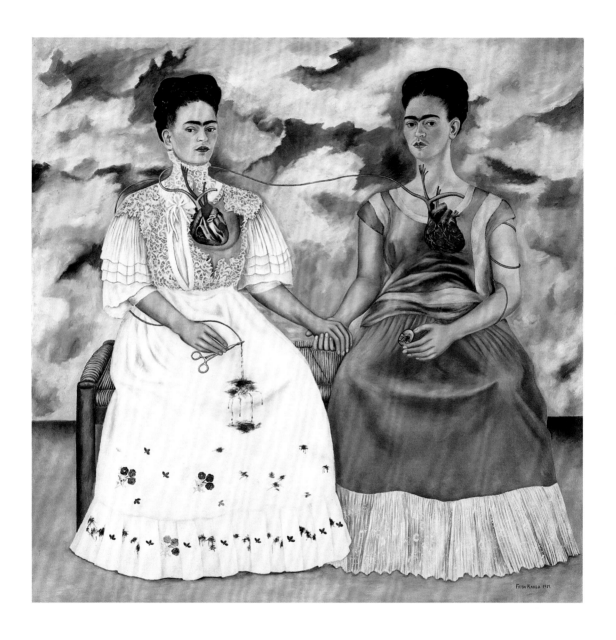

Fig. 9 Frida Kahlo, *Las dos Fridas*, 1939. Oil on canvas, 68⅛ × 68⅛ in. (173 × 173 cm). Museo Nacional de Arte Moderno, Mexico City

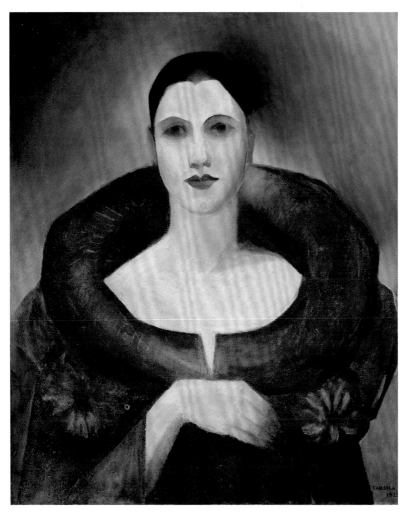

Fig. 10 Tarsila do Amaral, *Autorretrato (Le Manteau Rouge)*, 1923. Oil on canvas, 28¾ × 23¾ in. (73 × 60.5 cm). Museu Nacional de Belas Artes, Rio de Janeiro, Brazil

Amaral's Paul Poiret–designed red coat shares with First Lady Michelle Obama's high contrast "Milly Gown" a visual/psychological stop effect: a device that not only has narrative and regulatory functions, but inveigles viewers into a multi-layered image where persona and design liberally intersect to create a hybrid portrait/art statement: a reworking of Ingres's reconciliation of "nature" and "the ideal" but, in the hands of modern and contemporary women portraitists and their like-minded

and -gendered subjects, a reequipping and empowering of figurative art's female cohort.[17]

Compared to the great quantity of Western art depicting white women of different socioeconomic classes and states of notoriety, modern paintings and graphic art that portray African American women, especially before the 1970s, are relatively uncommon and generally unknown. After listing the iconic eighteenth-century engraving of the enslaved poet Phillis Wheatley; the early- to mid-twentieth-century paintings of maternal figures and Jazz-Age women by modernists Archibald J. Motley Jr., William H. Johnson, and Eldzier Cortor; sculptor and printmaker Elizabeth Catlett's emblematic *Negro Woman* series; and the circa 1940s paintings of black female achievers by artists Betsy Graves Reyneau and Laura Wheeler Waring, the painted portraits of other exemplary and distinguished African American women are too few for immediate recognition and, similarly, too scarce for earnest, scholarly considerations.[18] Such an "image wasteland," even at this current moment of a visual data surplus and hyper-visibility for black bodies, makes Amy Sherald's portrait of First Lady Michelle Obama all the more important. Consequently, the painting takes on the greater task of reminding the public of not just Michelle Obama's ceremonial status, attractiveness, and unique fashion sense, but of her many professional accomplishments, both academic and workaday, as first lady and outside of that role.[19]

Gratefully, the history of photography hasn't ignored African American women, and black women of renown—as well as the less noteworthy and the anonymous—form an expansive portfolio that spans the entire age of photography.[20] Amy Sherald's portrait of First Lady Michelle Obama responds in part to that photographic record and to the medium itself, translating photography's largely monochromatic palette into her sitter's painted refutation of an undemanding and one-dimensional racial categorization, wryly expressed by Sherald in defiant shades of gray. And, as a painterly retort to studio photography's cloistered *mise-en-scène* and calculated artifice, Sherald installs Michelle Obama and her other sitters against planar, studio-like backdrops that transform her subjects into silhouettes, emphatically flat and placard-like against intensely saturated hues. Configurations such as these, while

making plain the constructed nature and visual primacy of Sherald's painting, also draw viewers' attention to the cultural symbolism of her subjects and, in the case of First Lady Michelle Obama, the iconicity of the first African American woman in this position.

Photography's historical role in capturing the likenesses and advancing the reputations of illustrious African American women may have also figured in Amy Sherald's conceptualization. In February 2017, a previously unknown photograph of the former slave, Underground Railroad "conductor," abolitionist, and political activist Harriet Tubman was discovered and digitally circulated.[21] The studio portrait (fig. 11) by photographer Benjamin F. Powelson shows an approximately forty-something Tubman seated at an angle in a spindle-back chair, her skirt spread across the picture's whole width, and her visibly fit upper torso clad in a dark, ornate long sleeve and partly sheer blouse. Although there is no evidence that Sherald was aware of this photograph when she painted Michelle Obama, Tubman's flowing skirt, akimbo limbs, and posture bear a striking resemblance to Sherald's composition and, even assuming no direct influence, both portraits' pyramidal placements of their sitters against severe backgrounds along with their slightly averted poses and serious expressions create a meta-narrative of feminine strength that matches both Tubman and Obama's biographies. The bodily poses that the subjects of portraits typically take are certainly guided (and in some instances dictated) by the portraitists, but it is also conceivable that some sitters have as much to say about these attitudes and gestures as the artists: a prospect to consider in portraits of self-assured, forthright personalities such as Harriet Tubman and Michelle Obama.

Kehinde Wiley, like Amy Sherald, came into this assignment with a prior history in portraiture. At the beginning of the twenty-first century, Wiley's lively, tongue-in-cheek portraits of young African American men assuming the poses of saints, courtiers, and royalty from Renaissance, Baroque, and Neoclassical paintings in the grand manner—and further reinvigorated by the artist with stylish urban apparel and highly

Fig. 11 Benjamin F. Powelson, *Portrait of Harriet Tubman*, 1868 or 1869. Albumen silver print, 3¹¹⁄₁₆ × 2¼ in. (9.4 × 5.7 cm). Collection of the National Museum of African American History and Culture, Smithsonian Institution, shared with the Library of Congress

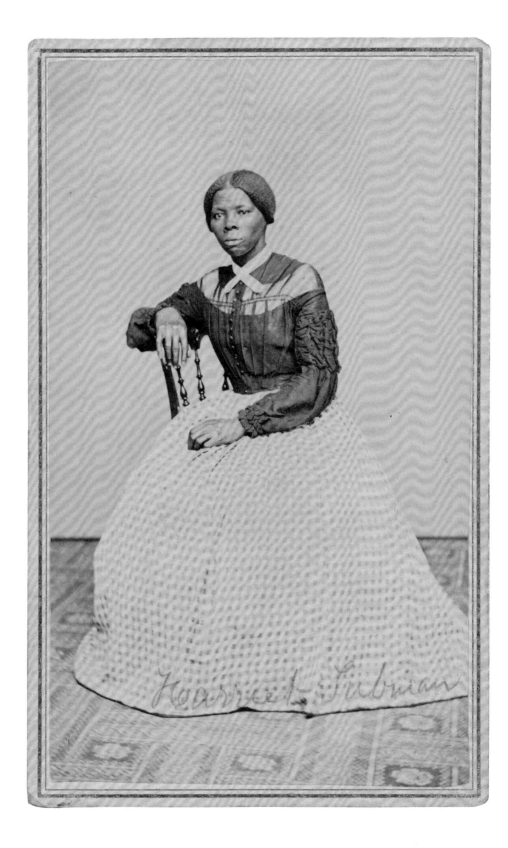

Harriet Tubman

embellished backgrounds—resurrected figurative art and raised the ante on more traditional modes of portraiture. Wiley's paintings initiated a conversation between contemporary art, hip-hop music, and popular black culture like nothing before him, offering a visual alternative to the glut of digital photography and, on the matter of reworking the black image, depicting men and women of African descent and other peoples of color in a revitalized and often redolent way. From hip-hop artists and pop musicians, such as LL Cool J (2005; see p. 17), Ice-T (2005), and Michael Jackson (2009), to star athletes and media figures like the Ivorian footballer Emmanuel Eboué (2010) and filmmaker Spike Lee (2014), Wiley's celebrity portraits garnered the attention of both the famed and the average person, prompting, for instance, his art to appear on *Empire* (2015–19), one of America's most-watched television dramas, and in journals and magazines as editorially diverse as the *Art Bulletin*, *Scholastic Art*, *Time*, the *New Yorker*, *Vogue*, and *Interview*.[22] Wiley's Old Masters templates and his enshrouding of black and brown bodies in decorative curvature and ornate filigree not only instated his subjects with a theatricality (and, at times, an incongruous grandeur), but these same elements also put an ironic, melancholy pallor over the pictorial proceedings, imposing a neo-Victorian, *memento mori* sense of ephemerality onto the already precarious social realities of many of his subjects.[23]

As coveted as a presidential portrait commission is, the responsibility and expectations such an undertaking ultimately present lessens the initial, heady perception of the commission and brings a measure of caution, even for an accomplished and celebrated artist like Kehinde Wiley. In spite of being more accustomed to painting entertainers and street-savvy youth in his characteristic "Afro-Baroque" fashion, Wiley was familiar with previous presidential portraits and no doubt noted the conservative character of this particular portrait class and the emotional gravitas these works typically show.[24] Two fairly well-known paintings of presidents— George Peter Alexander Healy's *Abraham Lincoln* (1869) and Douglas Chandor's 1945 portrait of Franklin Delano Roosevelt (within his *Study for the Big Three at Yalta)*—serve as illuminating, somewhat analogous counterparts to Wiley's painting and, through their compositions, décor, and figural emphases, demonstrate how the Obama portrait doesn't entirely depart from the genre's historical models (figs. 12–13). Like Healy's

Fig. 12 George Peter Alexander Healy, *Abraham Lincoln*, 1869. Oil on canvas, 73¾ × 55⅝ in. (187.3 × 141.3 cm). White House Collection / White House Historical Collection. (Note that there is a similar portrait of Lincoln, also by Healy, in the collection of the National Portrait Gallery.)

seated but forward-leaning President Lincoln, Wiley and President Obama selected a variation of this same pose, which, in addition to communicating attentiveness and engagement beyond the picture frame, favors taller-than-average portrait subjects. Wiley's decision to use an inlaid wood revival armchair within this otherwise contemporary image also harkens back to the portraits of President Lincoln and the previously discussed Harriet Tubman: furnishings that literally illustrate the time-honored act of "sitting" before the portraitist.[25]

Kehinde Wiley, a highly regarded African American artist, being commissioned to paint the portrait of Barack Obama, the first African American President of the United States, is a singular event in the annals of presidential portraiture. However, placing this historic painting alongside Chandor's depiction of President Roosevelt appoints Wiley's Obama portrait the newest example within an artistic continuum that makes portraiture's facial point of convergence compete with the subject's equally expressive hands (fig. 13). Upon President Roosevelt's late February 1945 return to Washington, DC—after a geopolitical summit at a Crimean resort with Great Britain's Prime Minister Winston Churchill and the Soviet Union's General Secretary Joseph Stalin—Chandor briefly met with the president at the White House, where he sketched him for a future group portrait of the three leaders that would commemorate their gathering. As it turned out, President Roosevelt died the following month, and because of Stalin's refusal to sit for the group portrait, Chandor abandoned the idea. Instead, the artist chose to paint an individual portrait of Churchill and left for posterity his upper torso study of Roosevelt, including a small sketch of the unexecuted *The Big Three at Yalta* and a series of oil studies of Roosevelt's hands.[26]

Similar to Chandor's multiple studies of President Roosevelt, Wiley's aptitude for painting physical likenesses is matched and possibly even surpassed by his compelling rendering of President Obama's hands. Bronze and pulsating against his dark suit, seemingly larger than normal, and gently folded across his lap, the president's hands function rhetorically, and like Roosevelt waving his spectacles or toying with a red pencil in Chandor's study, they wordlessly transmit both President Obama's legendary composure under pressure and, on a different front, a conceivable leaping into action. Here, Wiley demonstrates his deep knowledge

Fig. 13 Douglas Chandor, *Franklin D. Roosevelt* (study for *The Big Three at Yalta*), 1945. Oil on canvas, 43½ × 35½ in. (110.5 × 90.2 cm). National Portrait Gallery, Smithsonian Institution

of the Old Masters and their familiarity with corporeal and gestural languages: overtures to human beings and their capacities as performers on their own, improvised stages.[27]

In most of Wiley's paintings, the juxtaposition of the real and the artificial comprise the core visual element: subjects set against flat areas of brightly colored, antiquarian and/or mass-produced decorative patterns. His portrait of President Barack Obama departs from this formula, replacing the perspectiveless, textile-like background with an illusionistic wall of layered, thick green foliage and scattered flowers. Wiley incorporated a similar, somewhat naturalistic vegetal expanse surrounding a central figure in at least two paintings six years earlier: *Dacia Carter* (2012) and *Princess Victoire of Saxe-Coburg-Gotha* (2012), both from his *An Economy of Grace* series, which marked his first serious venture into portraying women. While rarely commented upon by critics (apart from listing the geographic symbolism of chrysanthemums, jasmine flowers, roses, and African blue lilies, and connecting these to the multiple itineraries of Obama's life), Wiley's natural backdrop in President Obama's portrait represents a thematic twist, creating a human/botanical *conversazione* that takes precedence over the more typical decorative anchors for Wiley's painted subjects.

In 1801, the Philadelphia artist Rembrandt Peale also created a combination human/plant portrait in *Rubens Peale with a Geranium* (fig. 14), a painting of his seventeen-year-old brother and aspiring botanist Rubens seated next to a zonal geranium (*Pelargonium inquinans*), one of the first tropical plants to be cultivated in the New World.[28] While nature in the Obama portrait certainly serves a decorative purpose, its stratiform treatment and occasional incursions into the president's personal space recall Peale's gangly geranium, a man-versus-nature idea that Wiley himself acknowledged, saying "there is a fight going on between [President Obama] and the foreground and with the plants that are . . . trying to announce themselves underneath his feet." "Who gets to be the star of the show," Wiley suggestively continues, "the story, or the man who inhabits that story?"[29] Wiley's artful transmutation in this exegesis of an encroaching "plant" into a spotlight-seeking "story" is telling, arming the portrait's botanicals with narrative powers that, similar to Peale's geranium, expand portraiture's language into the domain of nature and,

Fig. 14 Rembrandt Peale, *Rubens Peale with a Geranium*, 1801. Oil on canvas, 28⅛ × 24 in. (71.4 × 61 cm). National Gallery of Art, Washington, DC; Patrons' Permanent Fund

as suggested by the prominent human hands in both portraits, into the territories of cultivation and culture as well.

The narrative that President Barack Obama inhabits, and that the depicted vegetation and flowers presumably recount, is the story of countless Americans who, as the progeny of hard-working citizens, freedom-loving visionaries, and/or opportunity-seeking migrants, insist on a rightful seat in the Republic, with the understanding that both the nation's greatness and its still unfulfilled promise require them to metaphorically work its soil until it yields the fruits and bounties of the American dream. Seeing Wiley's portrait of President Obama in this part-documentary, part-allegorical way also brings it into dialogue with other artists and artworks for whom the garden is rife with social and political meaning. One especially finds in mid- to late nineteenth-century England, and in the works of a Pre-Raphaelite movement painter like Edward Burne-Jones, the sense that gardens and nature in general were the sites of cultural and moral education, and like Wiley's vegetal wall in the Obama portrait, their designs and plantings were meant to provoke thought as well as tell a story.[30]

At the height of the burgeoning black art scene in 1980s England, the artist Sonia Boyce, OBE RA, redeployed the efflorescent and decorative imagery that characterized the late nineteenth-century Arts and Crafts movement, declaring it as part of her Afro-Caribbean and British heritage and, similar to Wiley's embrace of ornamentation, incorporated stylized flora into her art. But in their respective works, both Boyce and Wiley fashioned a relational structure where the picture's implied "ground" purposefully collides and intersects with a foregrounded "figure" in order to establish a portrait formula in which everything within the picture frame equally matters. In the quadriptych *Lay back, keep quiet and think of what made Britain so great* (fig. 15), Boyce sardonically concocts the blackest of black roses and thorny canes to snake around a portrait of herself and three cruciform vignettes illustrating scenes from former colonies of the British Empire.[31] "Certainly," writes the literary critic Shirley Lau Wong about numerous Anglophone authors and their socially charged yet recondite writings about horticulture, "the world can never be left out of the garden," and, similarly, Wiley's verdant plot contains a nation and a world of possibilities.[32]

Fig. 15 Sonia Boyce, *Lay back, keep quiet and think of what made Britain so great*, 1986. Charcoal, pastel, and watercolor on paper, each panel 60 × 25⅝ in. (152.5 × 65 cm). Arts Council Collection, Southbank Centre, London

Fig. 16 Horace Pippin, *Man on a Bench (The Park Bench)*, 1946. Oil on canvas, 13 × 18 in.
(33 × 45.7 cm). Philadelphia Museum of Art; bequest of Daniel W. Dietrich II, 2016

Unveiled about a year after President Barack Obama ended his second term, Wiley's portrait carried a contemplative and somewhat introspective air, as if the stark aloneness of the president—except, presumably, for the wind rustling the leafy background and the scent of the assorted flowers in bloom—was just as crucial a part of the painting's story as the history contained in the embedded greenery. From Caspar David Friedrich's *Wanderer above the Sea of Fog* (1818) to Andrew Wyeth's *Christina's World* (1948), solitary figures in painted landscapes almost invariably carry the narrative of loneliness. No matter how obvious a portrait's fabricated world of solitude might be when compared to reality, viewers grab hold of the manufactured story line of reclusiveness and incorporate it into their interpretations of the subject.

An overarching sense of isolation in a constructed landscape is certainly present in the portrait of President Obama and, presciently, in another occupied pictorial idyll, *Man on a Bench,* by the early twentieth-century self-taught artist Horace Pippin (fig. 16). Painted toward the end of Pippin's life, *Man on a Bench* (also known as *The Park Bench*) used a near identical palette and many of the same visual strategies that Wiley would employ in the presidential portrait, signaling a common vision by two chronologically distinct painters that sought to artistically and psychologically capture on canvas a sojourner or, rather, a contender at the end of a professional and personal odyssey. Many historians have theorized that the figure in *Man on a Bench* is Pippin, and, with the idea that this picture's primary purpose was self-portraiture, the painting covertly takes up the sum of the artist's rollercoaster life and idiosyncratic career, encapsulated in an anonymous black man seated alone on a fire-engine red park bench, under an ochre canopy of leaves. Comparing Pippin's autumnal *mise-en-scène* with Wiley's flourishing hedge of green introduces yet another reading: the pairing of a cyclical metaphor with autobiography that, in the case of the Obama portrait, promises, or at least hopes for, a recurring season of new growth.[33]

Kehinde Wiley's painting of President Barack Obama and Amy Sherald's painting of First Lady Michelle Obama enter art history and, specifically, portraiture at a critical juncture. Between centuries of artistic production during which the portrait occupied an elevated status and a much shorter timespan, when such formerly inviolable notions

like verisimilitude and identity were questioned and probed by artists, these two portraits—by virtue of their governmental investitures and contemporary locus—bridged these conceptual models, existing in a diagnostic realm where not just each sitter's story and standing, but their symbolic value across many communities, shape the portraits' reception.[34] The subjects of these two portraits—historical, accomplished, atypical of the subjects of aggrandized, magisterial portraiture, and infinitely absorbing—lend themselves to current painting projects that, in conversation with art history and the various practices of portraiture, essentially upend those artistic antecedents, offering viewers something unexpected and new. Just as the Obama presidency showed the world a different face of America (again, not dissimilar from the multiracial narrative on the French wallpaper in the White House Reception Room), the Obama portraits inhabit an expanded genus, one where decorum, latitude, cultural authenticity, and an *au courant* sense of personal style predominate. Under the auspices of the National Portrait Gallery and their program to commission and acquire presidents' and first ladies' portraits, Wiley and Sherald would take this same American narrative of change, reformation, and the scenarios of a redolent landscape and generative background to an entirely different level, forever changing how the public views artistic representations of American notability, prestige, and service.

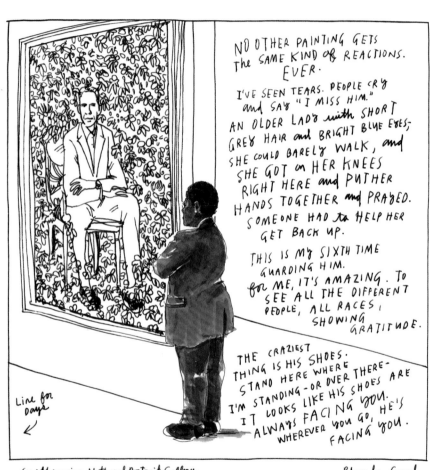

Fig. 1 Wendy MacNaughton, *Dispatch from DC*, 2018. Ink and watercolor on paper, 12 × 12 in. (30.5 × 30.5 cm). Collection of the artist

Kim Sajet

The Obama Portraits and the National Portrait Gallery as a Site of Secular Pilgrimage

Following her visit to the National Portrait Gallery in the spring of 2018, the artist Wendy MacNaughton created *Dispatch from DC*, a clever ink-and-watercolor drawing of Rhonda, a museum security guard, standing next to the newly unveiled portrait of President Barack Obama by Kehinde Wiley (fig. 1). In a hand-printed quote that appears in the drawing, Rhonda recounts how an elderly lady got down on her knees and prayed in front of the portrait in the company of other visitors. Summing up the experience, she told MacNaughton, "No other painting gets the same kind of reactions. Ever."

The artist posted a picture of her drawing on Instagram, and the image went viral. This was not entirely surprising because immediately after the unveiling of the Obama portraits, the museum's attendance had tripled. A month before MacNaughton's post, two-year-old Parker Curry had been captured on a smartphone, gazing in awe at First Lady Michelle Obama's portrait, painted by Amy Sherald (see p. 29). The resulting media sensation led the girl's mother to hire a publicist to manage all of the requests for interviews. Mrs. Obama, Parker told Ellen DeGeneres in front of a national audience, was a "queen."

As the director of the National Portrait Gallery, I had a front-row seat to this "Obama effect" and had to manage my dream scenario of watching thousands of visitors pouring through the doors.[1] The question I asked myself, given that we have hundreds of portraits of notable Americans on display, from George Washington to Beyoncé, was *why?*

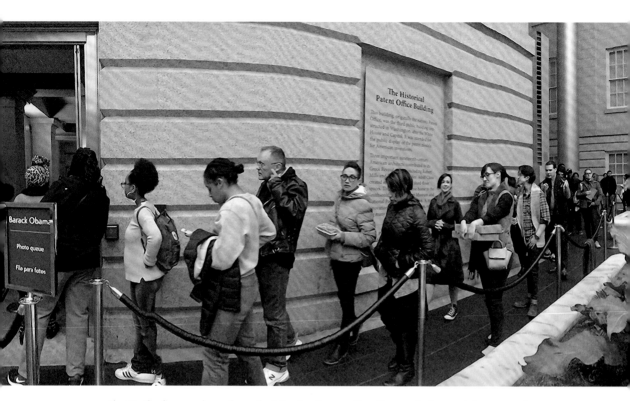

Fig. 2 In the days, weeks, and months following the unveiling, lines snaked around the museum's Robert and Arlene Kogod Courtyard and into the galleries. Some visitors waited hours to catch a glimpse of the portraits.

What was really happening? MacNaughton's illustration confirmed what I had begun to suspect: viewing these paintings was turning into a form of secular pilgrimage, and the museum was becoming even more popular as a communal gathering place (fig. 2).

Pilgrimage has been described as one of the oldest forms of tourism, undertaken by the faithful of all the world's major religions to restore a sense of order and meaning to their everyday lives. Anthropologists have suggested that such a journey involves people leaving the familiarity of home and undergoing a liminal experience, a disorienting voyage that brings them to the threshold of spiritual change—to Mecca since the time of the Prophet Muhammad, or to Jerusalem in the Middle Ages,

for example. In a state of heightened psychological awareness, pilgrims develop a sense of *communitas*, in which strangers on the same journey feel a sense of kinship with one another, allowing cultures to cross paths both real and symbolic. They return home with a renewed sense of hope.[2]

At first, pilgrimage was understood as religious, but later scholars allowed for the idea of a secular journey that could be just as powerful. Elvis Presley's home, Graceland, and Maya Lin's Vietnam Veterans Memorial in Washington, DC, have been called sites of contemporary pilgrimage. Any location, whether associated with a formal religion or not, can assume a "place-centered sacredness" by means of the significance that groups of people attach to it—whether for a short time, as

evidenced by roadside memorials, or long term, as seen by visits to the Tomb of the Unknown Soldier at Arlington Cemetery.[3]

The National Portrait Gallery occupies the "Old Patent Office" building, which briefly served as a field hospital during the Civil War. Author Walt Whitman considered the structure to be "that noblest of Washington buildings," and it was where President Abraham Lincoln held his second inaugural ball in March 1865.[4] Constructed out of the same type of sandstone used to build the Capitol and White House, the building was designed in the nineteenth-century Greek Revival style and modeled on the Parthenon in Athens (figs. 3–4). The architecture is intended to symbolize the highest ideals of Athenian democracy, whereby power is in the hands of the people and industrious individuals have the freedom to acquire wealth by their own means so long as they are governed by the rule of law. Originally meant to house a "church of the Republic," in the words of the city planner Pierre Charles L'Enfant,

Fig. 3 Edward Sachse and Co., Patent Office, c. 1855. Chromolithograph, 16 × 22 in. (40.6 × 55.9 cm). National Portrait Gallery, Smithsonian Institution

the Patent Office was envisioned as a temple of industry and national pride honoring America's technological superiority. In 1958, after years of abandonment and threats of demolition, Congress gave the building to the Smithsonian Institution to become, in part, the home of the National Portrait Gallery. In many ways, it is apropos, because at the museum we like to say that America's greatest invention has been its people.[5]

From the beginning, America refashioned portraiture as a tool of commerce and Republicanism that was aligned with the way innovation and inventions were regarded inside the Old Patent Office. The National Portrait Gallery's residence in porticoed splendor reinforced art historian Carol Duncan's idea that national museums made manifest the "imagined" community of the country-at-large.[6] Housing national treasures—and in respect to portraiture, treasured citizens—in palatial buildings resulted in the emergence of a philosophical belief that looking at great works of art and history is both spiritually uplifting and civically

Fig. 4 The National Portrait Gallery was founded by an Act of Congress in 1962 and opened in the Old Patent Office building in 1968. This photograph was taken after the museum's 2006 renovation.

important. Here, the general public, as opposed to the ruling class, is invited to leave the familiarity of home and enter a glorious civic space in order to encounter artifacts that were considered precious and iconic.

Before America signed the Declaration of Independence and formally broke with Britain, portraiture had long been regarded as an elite art form reserved for royalty and the European aristocracy. Considered an investment in advertising a family's influence, likenesses by fashionable artists were housed within palaces and family estates to be seen by only a privileged few. The founding of the National Portrait Gallery in Britain in 1856, however, marked a shift. One of its founders, the Earl of Stanhope, advocated private elitism as a vehicle for public pride; a celebration of British worthies, he believed, would make the museum a destination for secular enlightenment.

That idea of artistic patronage for national benefit crossed the Atlantic when the American industrialist Andrew Mellon stipulated in his will that his collection of fine portraits should be gifted to the nation and form the basis of a portrait gallery in Washington. The museum was eventually founded by an Act of Congress in 1962 and nested within the Smithsonian. Congress endowed the National Portrait Gallery with the additional "serious national purpose" of answering the question, *what is an American?*[7]

From the start, the museum tried to answer this question, accompanying its public opening with a book titled *The American: This New Man*. In it, the historian Oscar Handlin, quoting the French-American writer St. John de Crèvecoeur, defined an American as someone who had heroically left behind the "ancient prejudices and manners" of the Old World—this, despite the fact that the ideas of European racial superiority had transferred themselves to the New World, where they were used to justify Native American genocide and slavery. The idea of portraiture as an elitist art form also crossed the Atlantic: just like the European credo of *noblesse oblige*, American portraiture favored white men who owned land.

The result was that the museum's collection itself was largely pale and male, with stories of first contact, immigration, and bondage hard to come by or altogether absent. While Mellon donated a rare portrait of Pocahontas (fig. 5), and the Harmon Foundation a posthumous painting

of Harriet Tubman, it would take another few years to add Frederick Douglass and a decade to add Sojourner Truth. Restricted in no small measure by policies that prohibited photography or portraits of anyone who had not been dead for at least a decade, the museum's presentation of *E pluribus unum* ("Out of many, one") was more like *E pluribus lecti* ("Out of many, some").

Today's National Portrait Gallery includes Jimi Hendrix and Marilyn Monroe as well as Abraham Lincoln and Martin Luther King Jr.

Fig. 5 Unidentified artist, after Simon van de Passe, *Pocahontas*, after 1616. Oil on canvas, 30½ × 25½ in. (77.5 × 64.8 cm). National Portrait Gallery, Smithsonian Institution; transfer from the National Gallery of Art; gift of the A. W. Mellon Educational and Charitable Trust, 1942

Free admission allows visitors to decide for themselves whom they want to admire, creating a community that might share a cultural discourse tilted more toward Hollywood than holy scripture.[8] Where religious pilgrims once carried guidebooks and devotional texts to direct their journey, visitors today carry museum guides and mobile phones. Leaving the familiarities of their daily lives, they travel into these temple-like spaces to experience something emotional, something bigger than themselves. Echoing the prescribed routes of religious pilgrimage, visitors to the National Portrait Gallery might find a connection with *communitas*.[9]

Fig. 6 Alexander Gardner, after Mathew Brady Studio, *Abraham Lincoln*, 1861. Albumen silver print, 3⅜ × 2⅛ in. (8.6 × 5.4 cm). National Portrait Gallery, Smithsonian Institution

Fig. 7 *(opposite)* President Barack Obama, First Lady Michelle Obama, and their daughter Malia look at Alexander Gardner's 1865 photograph of Abraham Lincoln during a visit to the National Portrait Gallery in 2014.

The date of the Obama portraits' unveiling, deliberately chosen by Barack Obama, was February 12, Lincoln's birthday. The 44th president made no secret that he admired the 16th (figs. 6–7). He launched his presidential campaign in Lincoln's hometown of Springfield, Illinois; held the Lincoln Bible at his swearing-in; and often remarked that Lincoln's abolition of slavery had made his presidency possible.[10] Like Lincoln, the first president to savvily use photography of himself to connect with the American people, Obama's presidency had been marked by an understanding of the power of portraiture.

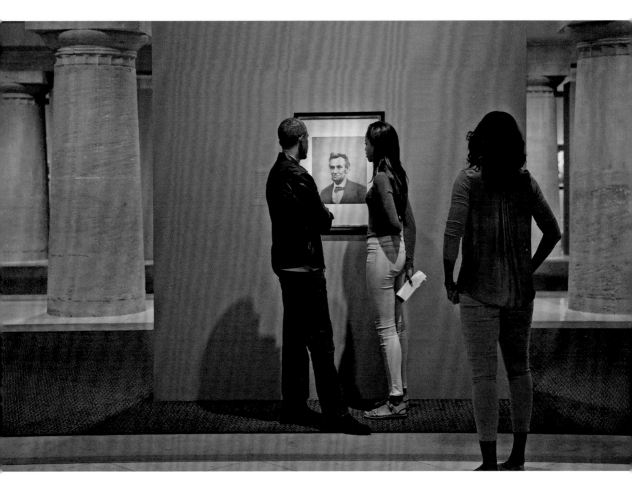

Fig. 8 Robert A. Anderson, *George W. Bush*, 2008. Oil on canvas, 52⅛ × 36½ in. (132.4 × 92.7 cm). National Portrait Gallery, Smithsonian Institution; gift of American Fidelity Foundation, J. Thomas and Stefanie Atherton, William S. and Ann Atherton, Dr. Jon C. and Jane G. Axton, Dr. Lee and Sherry Beasley, Thomas A. Cellucci, A. James Clark, Richard H. Collins, Edward and Kaye Cook, Don and Alice Dahlgren, Mr. and Mrs. James L. Easton, Robert Edmund, Robert and Nancy Payne Ellis, Dr. Tom and Cheryl Hewett, Dr. Dodge and Lori Hill, Pete and Shelley Kourtis, Tom and Judy Love, David L. McCombs, Tom and Brenda McDaniel, Herman and LaDonna Meinders, The Norick Family, Kenneth and Gail Ochs, Robert and Sylvia Slater, Richard L. Thurston, Lew and Myra Ward, Dr. James and Susan Wendelken, Jim and Jill Williams

Kehinde Wiley and Amy Sherald, the artists the Obamas chose, were the first African Americans to paint the portraits of a president or first lady for the National Portrait Gallery, and from the moment of the unveiling, it was clear that the two had both borrowed from and broken with the canon of traditional portraiture. Wiley chose to seat the president in a chair, wearing a suit but no tie, looking directly out of the canvas at the viewer. The pose is similar to that of George Peter Alexander Healy's Abraham Lincoln (see p. 69), Elaine de Kooning's John F. Kennedy (see p. 5), and Robert Anderson's George W. Bush (fig. 8), all portraits Wiley had seen on walks through the galleries. But it was the background of rampant foliage and flowers symbolizing periods of the president's life—chrysanthemums for Chicago, jasmine for Hawai'i and Indonesia, African lilies for Kenya, and rosebuds for love—that was so extraordinary, making Obama appear at once timeless and contemporary.

The portrait of Michelle Obama elicited more commentary. Attired in a geometrically patterned dress by the designer Michelle Smith, which reminded the artist of modernist art and Gee's Bend quilts created by the descendants of enslaved people, the former first lady was presented as both modern and historical. The rendering of her skin as gray, as the *New York Times* art critic Roberta Smith wrote, "introduces the notion of double consciousness, the phrase coined by W. E. B. Du Bois to describe the condition of anyone living with social and economic inequality."[11] Or, as the critic Antwaun Sargent noted more succinctly in *W* magazine, what viewers were witnessing were "visions of black power [shaking] up a gallery of white history."[12]

Watching viewers in front of the portraits, it is clear that the celebrity of the Obamas cannot be underestimated. As Michael Dyson of Georgetown University has remarked, Barack Obama, as the first African American president, "shocked the symbol system of American politics."[13] In the gallery, his black body palpably ruptured America's white ruling class and served as a poignant expansion of what blackness and presidential power could be in America—and maybe, in the eyes of the museum's new pilgrims, what America could be, too. Michelle Obama's portrait, meanwhile, shares resonance with the former first lady's instant best seller of an autobiography, which, as the writer Emily Lordi noted in the *New Yorker*, "draws on the literature of black women's

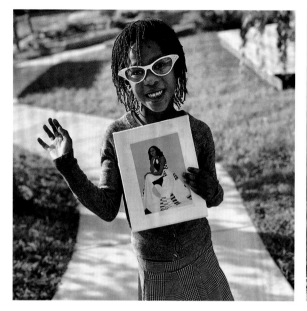

Fig. 9 After visiting the National Portrait Gallery in the fall of 2018, Raegan Waddy was inspired to dress up as Amy Sherald for Halloween.

Fig. 10 Sherald's portrait of Michelle Obama inspired a number of popular social media posts.

self-making."[14] In her depiction of Obama, Sherald turned traditional portraiture on its head; for both women, being "seen" via portraiture appears to be an important step in claiming their space. Certainly when Parker Curry (see p. 29) and another little girl called Raegan Waddy dressed for Halloween as Michelle Obama and Amy Sherald (fig. 9), respectively, and posted their costumes on Instagram, the elitist tradition of portraiture was transformed by their joyful faith that they, too, could grow up to become such strong women.

The portraits themselves have become a pop-culture reference, replicated in Peeps dioramas, children's clothes (fig. 10), lunch bags (fig. 11), a host of online memes, and even on television.[15] This level of cultural impact and ubiquity forces us to consider the "Obama effect" in relation to the fifty-year history of the National Portrait Gallery—or, more broadly, the history of the United States. Given America's "original sin" of slavery by the congregation of the Founding Fathers in 1787, there is significance in the fact that it took the portraits of the first black president and first

lady to rekindle a sense of pilgrimage within a space originally intended to elevate secular America.

Today, the lines continue, with people of all backgrounds queuing up to take a photo in front of the portraits and buy bespoke merchandise in the store (figs. 12–13). And for most, the gallery offers something more—a site where visitors can engage in a special social bond, each sharing in a liminal space that is heavy with meaning and wonder.[16] As Savannah,

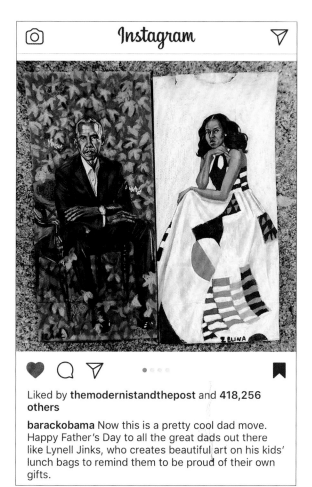

Fig. 11 Artist Lynell Jinks routinely illustrates his children's lunch bags. After Jinks posted a photograph of these drawings on his Instagram account in April 2018, President Obama shared the post on his feed.

one of our visitors, said, "To me [the Obama portraits] are period icons, and it remains to be seen if they are documents of a fleeting moment, or a new century." Whatever the outcome may be, this much remains true: whoever chooses to visit these paintings can claim a special moment for themselves that is not only about transition but also about potentiality—a pilgrimage from the past and into the future, with a brief opportunity to reflect on how far we have come and how much further we still have to go.

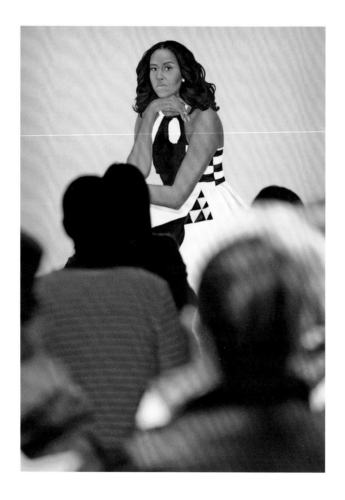

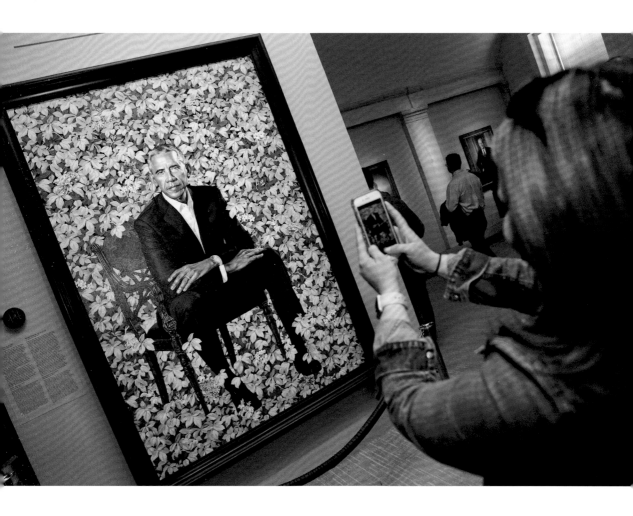

Figs. 12 and 13 The National Portrait Gallery welcomed more than two million visitors in FY2018, nearly doubling its annual attendance records. Most individuals who came to see the portraits in person used their phones to document their personal encounters.

Monday, February 12, 2018

The Presentation of the Obama Portraits

A Transcript of the Unveiling Ceremony

ANNOUNCER: Ladies and gentlemen, please welcome to the podium Kim Sajet, Director of the Smithsonian National Portrait Gallery.

KIM SAJET: Good morning. My name is Kim Sajet, and it is my pleasure, as director, to welcome you to the National Portrait Gallery at the Smithsonian Institution. Every commissioned portrait involves four people. The first person is the sitter, who already has a larger than life persona, and may—understandably—be rather curious to see how his or her likeness will be captured in perpetuity. In a spirit then of building anticipation, I bid a warm welcome to the 44th President of the United States, Barack Obama, and former First Lady Michelle Obama, whom we honor today.

The second person is the artist, who tries—in the face of public scrutiny—to stay true to her or his own artistic style, and still transmit a sense of their sitter's internal spirit to external audiences. In many ways,

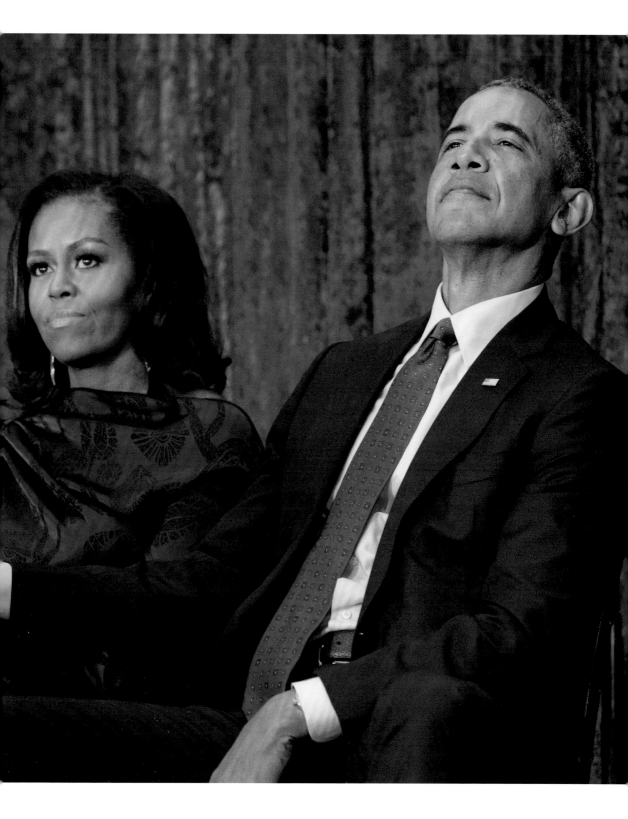

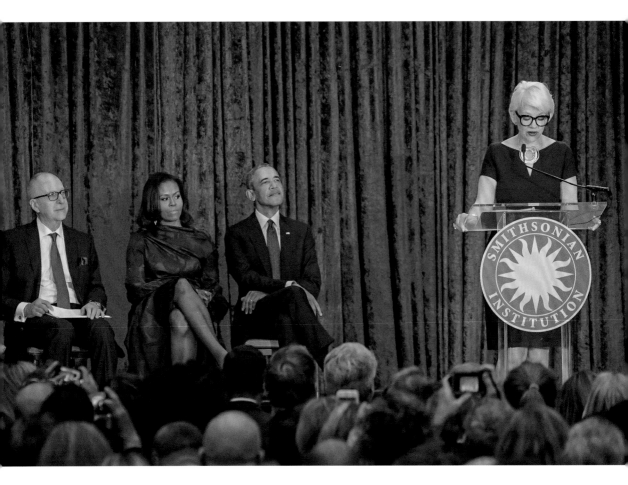

as much a reflection of themselves as an insight into their subject, the portrait artist must remain unique and, to quote the poet Baudelaire, "realize a character." In the spirit of that bravery, I am thrilled to welcome Kehinde Wiley and Amy Sherald into our collection. This museum had the pleasure of showing Kehinde's work in 2008, as part of the *Hip Hop and Contemporary Portraiture* exhibition. And Amy Sherald we celebrated in 2016, when she became the first woman to win our Outwin Boochever Portrait Competition.

Kehinde and Amy are taking the best of portraiture traditions and adding a fresh layer by absorbing the influences of fashion, music, hip-hop, pop culture, and painterly inventiveness. Together, they are transmitting the energy of urban America into the contemplative spaces of high culture, and I—for one—am thrilled.

The third person involved in making a commission is the patron. And as is tradition, we make an art match, and then we raise private funds to do the work. I am extraordinarily grateful to all of those people

across the country, to whom we came for support, and those who took a leadership role: Steven Spielberg and Kate Capshaw, Judith Kern and Kent Whealy, and Tom Pegues and Don Capoccia.

Finally, it is the fourth person that is possibly the most important: you—the viewer, and generations to come. At the end of the day, the sitter, the artist, and even the donors will disappear, but it is the audience that will remain. Every portrait, no matter when it was created, is contemporary because it is completed when someone has a personal encounter in their time. Ultimately, these portraits will live to serve those millions of future visitors looking for a mentor, some inspiration, and a sense of community. Ironically, for this art museum it's not what you look like that counts; it's what you do that matters. And through the skill of a talented artist providing a window into the life of a president and first lady, people learn history and their place in it, set the course of human events in context, find empathy for others, and, perhaps, create a sense of connection that leaves them feeling a little less alone.

Thank you.

ANNOUNCER: Ladies and gentlemen, please welcome to the podium David Skorton, Secretary of the Smithsonian Institution.

DAVID SKORTON: Good morning everyone, and thank you for joining us on a very, very special day at the Smithsonian. President Obama, Mrs. Obama, Vice President Biden, Amy, Kehinde, Kim, Provost John Davis, regents, commissioners, and distinguished guests, it is an honor and privilege to share this morning with you. As you probably know, we have two occasions to celebrate today. First, in just a few moments, President and Mrs. Obama will unveil their official portraits. And second, today is Abraham Lincoln's birthday. What you may not know is that President Lincoln once credited a portrait with getting him elected: a photograph by the great Mathew Brady taken before Lincoln's famous speech at the Cooper Union, in February 1860. For many Americans in 1860, this was the only Lincoln they knew. The Brady image appeared on the cover of *Harper's Weekly*, in newspapers across the country, and on buttons and leaflets throughout the campaign. Today, that photograph is on display here at the National Portrait Gallery.

Lincoln may have given Brady too much credit. There were probably a few other reasons he won the presidency. For example: I hear he was a pretty good speaker. But his comment reflected something that was true back then and remains true more than a century and a half later. Presidential portraits have a particular power to capture the public imagination. To move people to think about America's leaders, and indeed American society itself, in new and unexpected ways. This is why the Portrait Gallery has been collecting presidential portraits for fifty years. And it's why we have expanded that collection to include our nation's first ladies. We are excited to continue both of those traditions today. And I want to stop for a moment and ask you to join me in recognizing the ongoing innovations of Portrait

Gallery Director Kim Sajet and her magnificent colleagues, who are continually reimagining ways in which the Portrait Gallery can inform and inspire the American public and beyond.

Kim, congratulations.

Now if you think back, just a little bit, you may remember another image that drew national attention, just a couple of years ago. It captured a tender moment at the opening of the National Museum of African American History and Culture. Former President George W. Bush was embracing—or rather—being embraced by first lady Michelle Obama. One headline called it "The Hug Felt Around the Country." I can only speculate as to what exactly made that image so moving to so many people. But when I look at that picture today, I can see clearly some of the many qualities that millions of Americans have admired, and continue to admire, in Michelle Obama for over a decade. Her warmth, her kindness, her ability to connect in real and meaningful ways, with virtually

everyone she encounters. As the first African American woman to serve as first lady, Michelle Obama blazed a trail for women and girls of color and inspired countless women, men, and children across the United States and around the world. During her eight years in the White House, she was a tireless advocate for causes that transcend partisan politics: fighting to end childhood obesity, encouraging young people to pursue higher education, supporting our service members and their families, and working to ensure that girls around the world can, and will, go to school. Even more impressive, she did all of this while raising two remarkable daughters, and did it always with good humor and grace.

Dear to my heart, Mrs. Obama also continues to be a devoted champion of the arts. And we need the arts, so much, in every day of our lives. As first lady, she helped give African American artists a greater presence on the walls of the White House. A commitment that her selection of Amy Sherald to

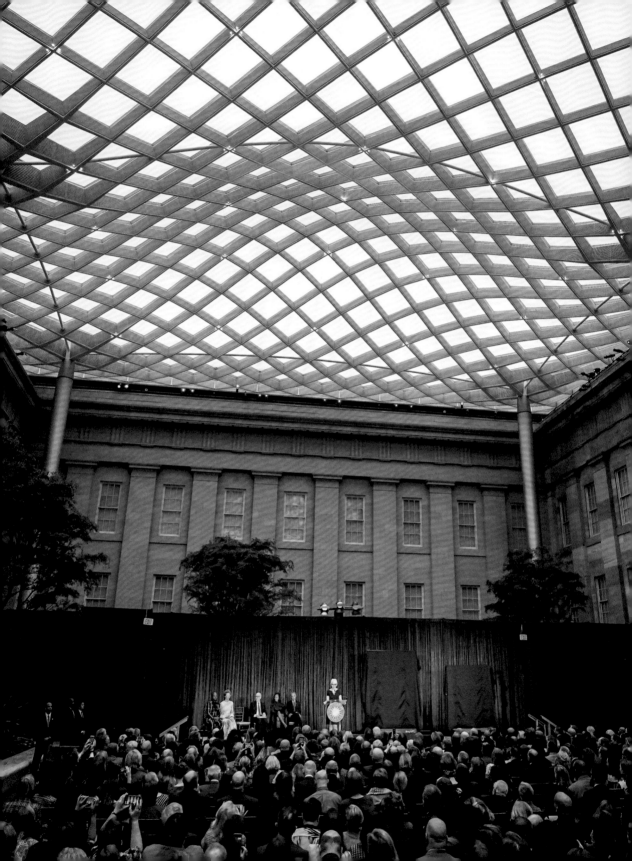

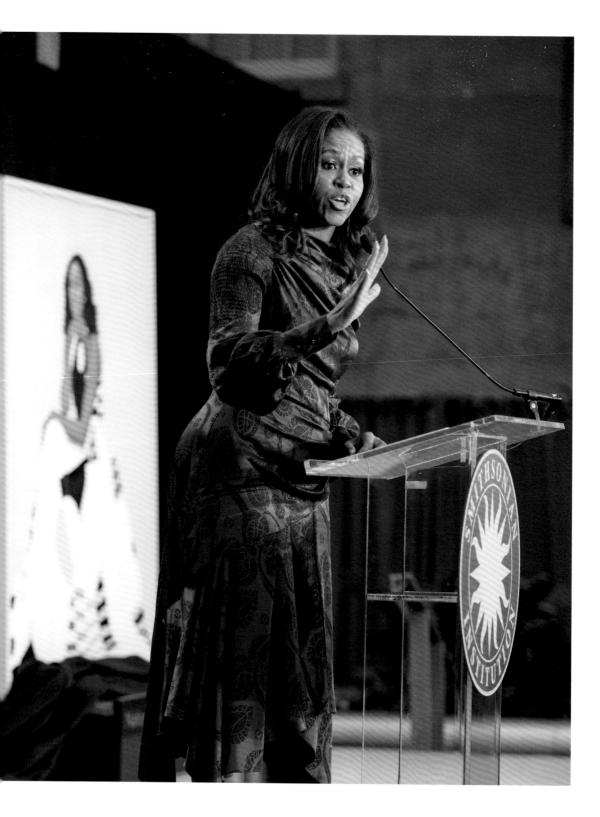

paint her portrait reflects, and one that we at the Smithsonian here are so proud to share. And now, it is my honor and privilege to invite Mrs. Obama and Amy Sherald to unveil the portrait.

MRS. MICHELLE OBAMA: Good morning everyone. Let's just start by saying, "wow," again. Let me just take a minute. It's amazing. Wow!

Well, it is a pleasure and an honor to be here in this beautiful museum with all of you today. Let me start, of course, by thanking Secretary Skorton and Kim Sajet for their remarks and for their outstanding leadership and everything they have done to support us, to support the arts over these many, many years. I also want to recognize all of our dear friends, and colleagues, and our team members, and our family who are here with us today—too many to mention—Joe, and I know Jill's in traffic. Thank you, thank you all for being here. We love you.

Hi Mom. What's going on? What do you think? It's pretty nice, isn't it?

I see so many people I could thank, people who have been with us on this journey. We love you all. Thank you for taking the time. I have to tell you that as I stand here today, with all of you, and look at this amazing

portrait that will hang among so many iconic figures, I am a little overwhelmed, to say the least. I have so many thoughts and feelings rolling around inside of me now: I am humbled, I am honored, I'm proud. But most of all, I am so incredibly grateful to all the people who came before me in this journey. The folks who built the foundation upon which I stand. As you may have guessed, I don't think there is anybody in my family who has ever had a portrait done, let alone a portrait that will be hanging in the National Portrait Gallery. At least, as far as I know, Mom.

But all those folks who helped me be here today, they're with us physically, and they're with us in spirit. I am thinking about my grandparents, Rebecca and Purnell Shields, "South Side," as he is known now throughout the nation. LaVaughn and Fraser Robinson Jr. They were all intelligent, highly capable men and women. They have the kind of talent and work ethic that usually destines people for greatness. But their dreams and aspirations were limited because of the color of their skin. I am, of course, thinking about my dad, Fraser Robinson III. A man who sacrificed everything to give me and my brother opportunities he never dreamed for himself. And of course I'm thinking about my mommy, Marian Robinson, who is sitting in the front row, supporting us—like she has always done—always putting herself last on her list so that she could give me and Craig, and our children, everything that makes today possible.

I'm also thinking about all of the young people, particularly girls, and girls of color—who in years ahead will come to this place,

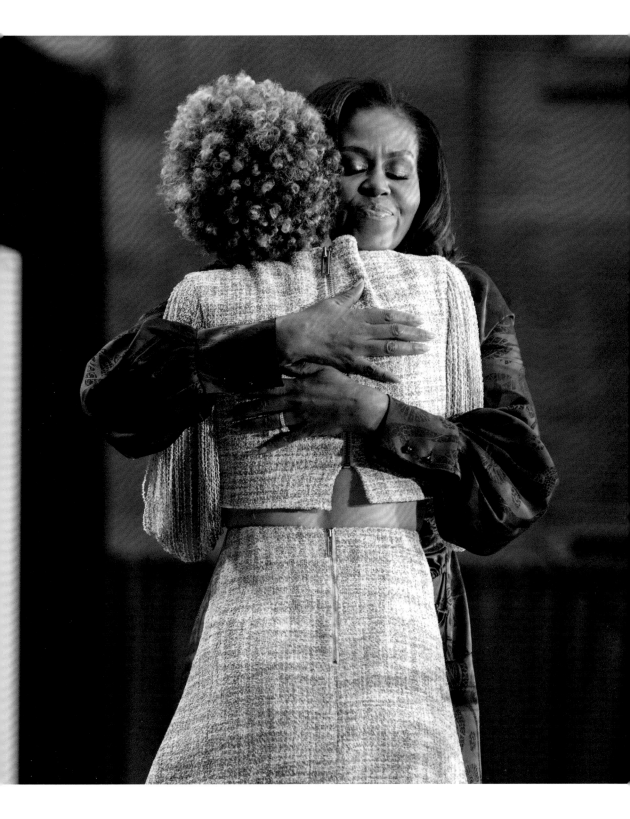

and they will look up and they will see an image of someone who looks like them, hanging on the wall of this great American institution. Yeah.

And I know the kind of impact that will have on their lives because I was one of those girls. And when I think about those future generations, and generations past, I think again—wow, wow. What an incredible journey we are on together in this country. We have come so far. And yes, as we see today, we still have a lot more work to do. But we have every reason to be hopeful and proud. And I am truly grateful to have had the opportunity to stand alongside my husband and play a very small part in that history and in that future. But I'm even more proud of the extraordinary woman and artist who made this portrait possible, Amy Sherald.

Now, Barack and I had the privilege of considering a number of outstanding portraitists, and I want to thank Bill Allman, Thelma Golden, Michael Smith, our team— we love you guys, I know you're out there— who guided us every step of the way through this process. We never could have done this without you, because you not only know your craft and all these folks, but you know us intimately; you knew what we were looking for and what we wanted to say. So thank you three, the dynamic trio. And with their help we narrowed down the field to a few key artists who Barack and I then interviewed. And each of these artists had to walk into the Oval Office—yikes!—and I almost wanted to start off each conversation by apologizing for putting them through this process. I mean, just to get this job they had to come

to the White House, to the Oval Office, and get grilled by the president and first lady. I'm sorry. I'm so sorry.

So, it wasn't lost on us how unnerving this experience was for each and every one of them, and when Amy came in, and it was her turn, I have to admit that I was intrigued. I was intrigued before she walked into the room. I had seen her work, and I was blown away by the boldness of her colors and the uniqueness of her subject matter. So I was wondering, who is this woman? And she's so cute, too! And then she walked in and she was fly and poised, and I just wanted to stare at her for a minute. She had this lightness and freshness of personality; she was hip and cool in that totally expected-unexpected kind of way. And within the first few sentences of our conversation, I knew she was the one for me, and maybe it was the moment she came in and she looked at Barack and she said, "Well, Mr. President, I'm really excited to be here, and I know I'm being considered for both portraits," she said, "but, Mrs. Obama"—she physically turned to me, and she said—"I'm really hoping that you and I can work together."

And after that, she and I—we started talking—and Barack kind of faded into the woodwork. And, you know, there was an instant connection, that kind of sister-girl connection that I had with this woman, and that was true all the way through the process. Which is a good thing, because when someone is doing your portrait, they spend hours staring at you—yikes! It's very intimate, the experience, so you really have to trust the person and feel comfortable enough to let

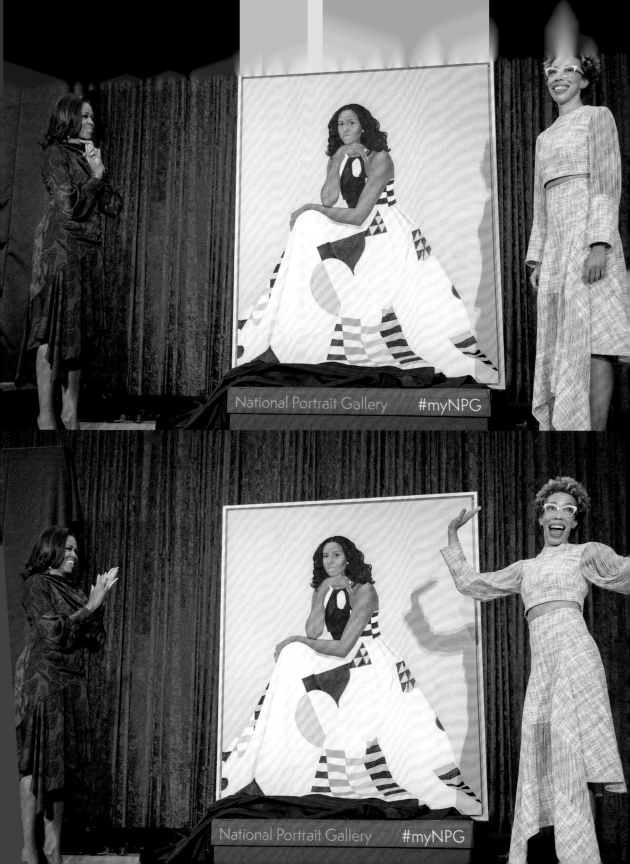

National Portrait Gallery #myNPG

yourself go. And Amy made that possible for me; we had that connection. So today, I want to thank Amy for being willing to put herself through this process, especially after it was leaked. I just felt for you girl. You know, to have to do that, right? To paint a portrait of Michelle and Barack Obama is like cooking Thanksgiving dinner for strangers. Everybody has an idea of what Thanksgiving dinner is supposed to taste like. The dressing that you love is the dressing you love! You don't want other stuff in it. And that's what it's like. People, people know what they feel, and think, and how they see us. So, Amy had to interpret that and do it under the spotlight. So I can only imagine that it's been a little stressful for her, but she has handled it all with remarkable poise and grace, which I think tells you a lot about who she is.

She is obviously a woman of extraordinary talent, and it is thrilling to see her getting the recognition she deserves, with all the awards and the calls from museums and buyers lining up to purchase her work. But even more important, Amy is a woman of extraordinary character and strength. Her path has been strewn with obstacle after obstacle. She's faced life-threatening medical conditions of her own; she's made tremendous sacrifices to care for the people she loves; she's endured the heartbreak of losing some of those that she has loved; and all through it, she kept going. All along, she stayed faithful to her gifts, she refused to give up on what she had to offer to the world, and as a result, she is well on her way to distinguishing herself as one of the great artists of her generation. It was a total joy.

It was a total joy to work with you, Amy. I am so pleased and honored and proud of you. So it is my honor to introduce Amy to all of you today, the woman who created this beautiful portrait, Amy Sherald.

AMY SHERALD: Good morning. Thanks for being here so early. Mrs. Obama, I want to begin by saying thank you. Thank you for

seeing my vision, and thank you for being a part of my vision. I paint American people. And I tell American stories through the paintings I create. I find my models, I style them, and I photograph them. I then use that photograph as a reference. My approach to portraiture is conceptual. Once my paintings are complete, the model no longer lives in that painting as themselves. I see some-thing bigger, more symbolic. An archetype. So approaching the commission with you as the subject of this painting is deeply con-nected to what I hold as my truth. This por-trait delivers the same kind of symbolism.

The dress chosen for this painting was designed by Milly. It has an abstract pattern that reminded me of the Dutch artist Piet Mondrian's geometric paintings. But Milly's

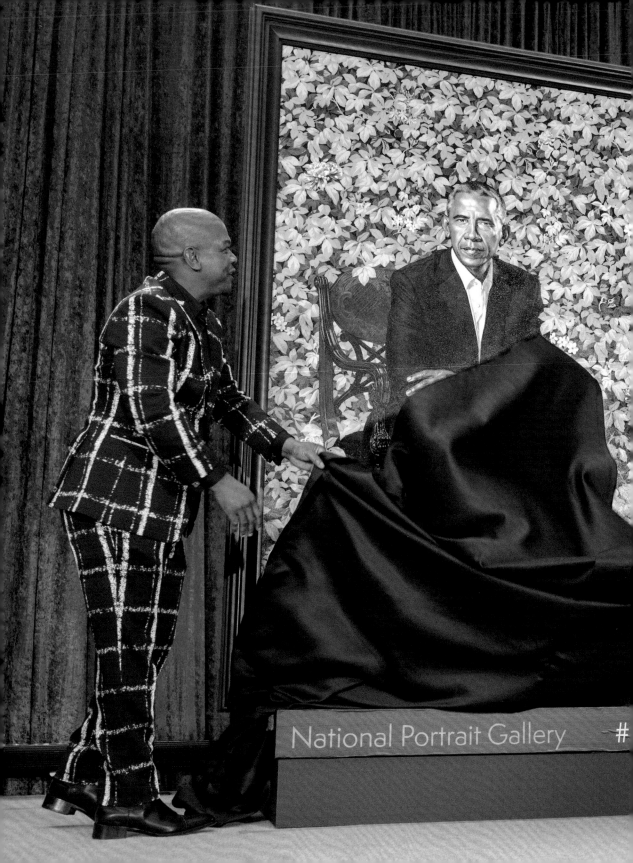

National Portrait Gallery #

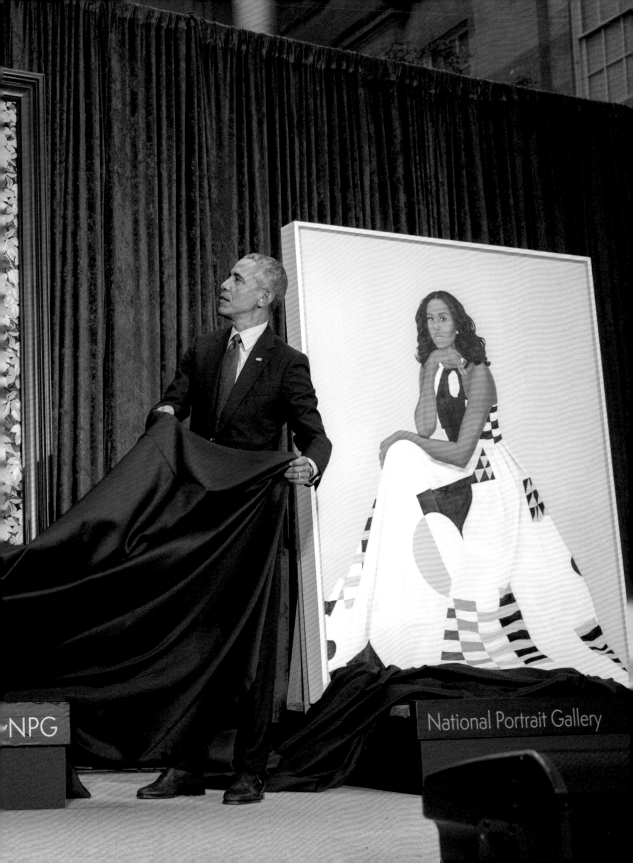

NPG

National Portrait Gallery

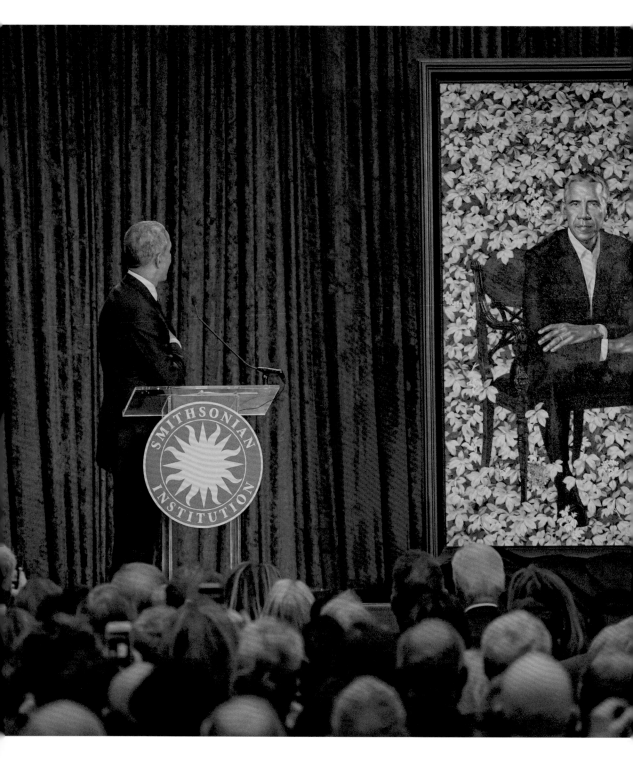

design also resembles the inspired quilt masterpieces made by the women of Gee's Bend—a small, remote, black community in Alabama, where they compose quilts and geometries that transform clothes and fabric remnants into masterpieces. Photographer and historian Deborah Willis wrote, "you have engaged the imagination of a new generation of writers and artists, as we chronicle the commanding role you played in American visual culture."

Mrs. Obama, you are omnipresent in that way. You exist in our minds and our hearts in the way that you do because we can see ourselves in you. The act of Michelle Obama being her authentic self became a profound statement that engaged all of us. Because what you represent to this country is an ideal. A human being, with integrity, intellect, confidence, and compassion.

And the paintings I create aspire to express these attributes. A message of humanity. And I like to think that they hold the same possibilities of being read universally. So, I will always be grateful for this enormous opportunity to work with you. This experience has humbled, has honored, and informed me in ways that will stay with me forever. So thank you again for bringing light and clarity to my journey as a painter of American stories, and I truly consider today to be a defining milestone in my life's work.

And I just want to say—without crying—a quick thank you to my mom for supporting me all the way through.

SKORTON: Thank you Mrs. Obama, thank you Amy. President Obama, I know of all the

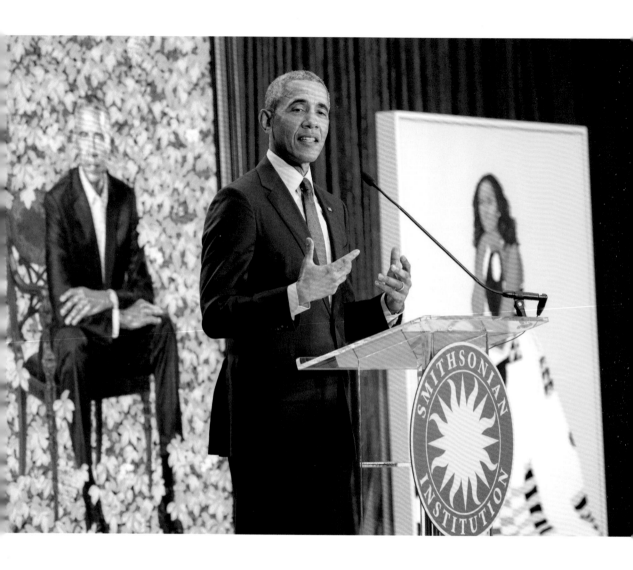

people here, you are aware that your wife is a tough act to follow.

I hope, sir, that you are more prepared than I am. It's hard to believe, isn't it? That just eleven years have passed since Barack Obama launched his presidential campaign in Abraham Lincoln's hometown of Spring-field, Illinois. In fact, it was eleven years ago this very week. Some of you might recall that when he addressed the crowd outside the old state capitol, he quoted a speech in which Lincoln observed the strange, discordant, and even hostile elements that America confronted in 1858. At the time of President Obama's inauguration, America again faced challenges that could be described in quite similar terms. A global economic crisis, wars in Iraq and Afghanistan, rapid technological progress, and the rising uncertainty that came with that progress. And

during a period of such profound change in the country and the world, President Obama provided the steady leadership that millions of Americans were seeking. He was a voice of calm in times of chaos. He was a voice of comfort in times of grief. And he was a voice of confidence at all times. Confidence in the resilience of the American people and the promise of a better future for all. In one important sense, President Obama's historic election was a departure from America's past, but he also embodied the ideals that defined some of the other presidents portrayed in these halls: Lincoln's secular faith in our national Union; Kennedy's commitment to public service; Reagan's optimism that America's best days are still to come. For these reasons and more, Barack Obama was a very consequential president. He will long be the subject of admiration, study, and fascination. And when future generations look back at this presidency, I believe that Kehinde Wiley's portrait will give them a unique window in the way that only presidential portraits can. A window into both the man and the moment when he led with such distinction. And with that, please join me in inviting President Barack Obama and Kehinde Wiley to unveil the portrait.

PRESIDENT BARACK OBAMA: Well, good morning everybody. It is wonderful to see all of you. How 'bout that [portrait]? That's pretty sharp. It is my great honor to be here, and I want to thank Secretary Skorton and Kim for your outstanding leadership at a couple of the crown jewels of American life, and your extraordinary stewardship. I want to thank everybody who is here. Michelle

and I are so grateful for the friends, family, former staff, and current staff who have taken the time to be here and honor us in this way, and soak in the extraordinary art that we're seeing here. It means so much to us, and I hope you're aware of that. We miss you guys, and we miss the way those who worked with us on this incredible journey carried yourselves and worked so hard to make this country a better place. Amy, I want to thank you for so spectacularly capturing the grace, and beauty, and intelligence, and charm, and hotness of the woman that I love.

Special shout-out to my man, Joe Biden. An even more special shout-out to my mother-in-law, who in addition to providing the hotness genes, also has been such an extraordinary rock and foundational stone for our family. And we are so, so grateful to her. We love her so much.

Like Michelle, I have never had a portrait done of myself. I mean, the "Hope" poster by Shep was cool, but I didn't sit for it. Nobody in my family tree, as far as I can tell, had a portrait done. I do have my high school yearbook picture, which is no great shakes. And so when I heard that this was part of the tradition, I didn't quite know what to do. Michelle and I were somewhat confused. We were lucky to have some extraordinary friends and people with exquisite tastes—Bill Allman, Thelma Golden, and Michael Smith, who gave us the assist and helped us to consider a whole range of artists. And we had an immediate connection with the two artists that are sitting here today. I think it's fair to say that Kehinde and I bonded, maybe not in the same way,

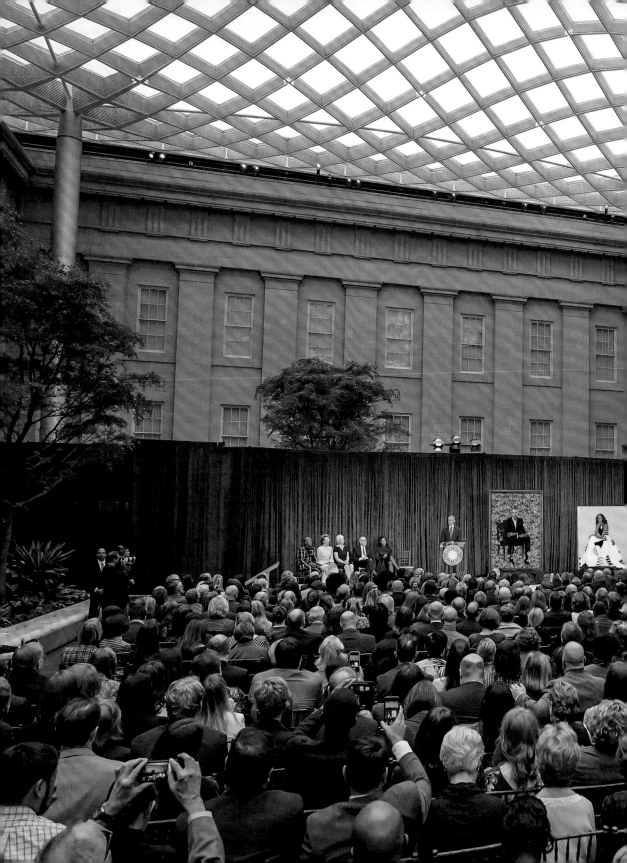

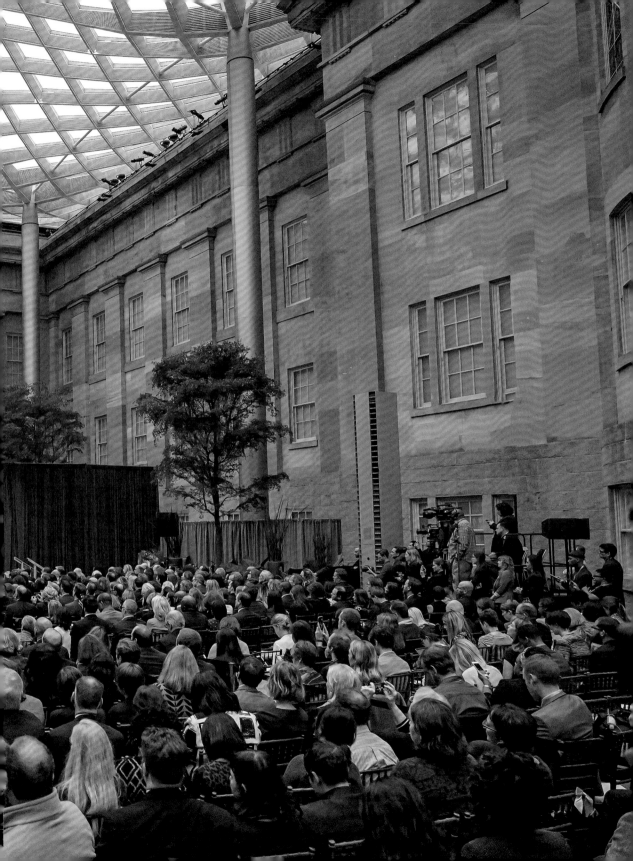

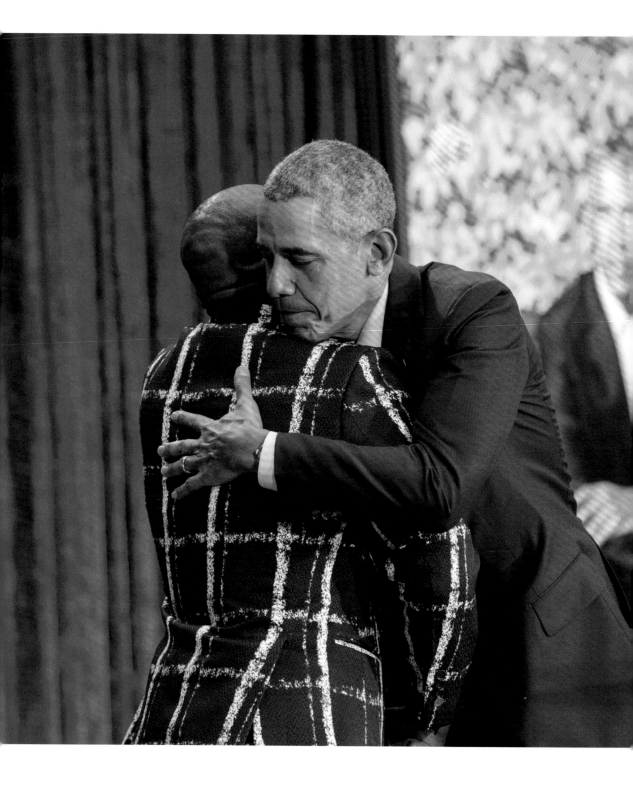

this whole "sister-girl" you know, thing. I mean, we shook hands, we were—you know, we had a nice conversation. He and I make different sartorial decisions. But, what we did find was that we had certain things in common.

Both of us had American mothers, who raised us with extraordinary love and support. Both of us had African fathers, who had been absent from our lives, and in some ways our journeys involved searching for them and figuring out what that meant. I ended up writing about that journey and channeling it into the work that I did—because I cannot paint. I'm sure that Kehinde's journey reflected some of those feelings in his art. But what I was always struck by, whenever I saw his portraits, was the degree to which they challenged our conventional views of power and privilege. And the way that he would take extraordinary care, and precision, and vision in recognizing the beauty and the grace and the dignity of people who are so often invisible in our lives. And put them on a grand stage, on a grand scale. And force us to look and see them in ways that, so often, they were not. The people that Michelle referred to, people in our families, people who helped to build this country, the people who helped to build this capital, people who to this day are making sure that this place is clean at night, and serving food, and taking out the garbage, and doing all the other stuff that makes this country work. So often out of sight and out of mind. Kehinde lifted them up and gave them a platform and said they belonged at the center of American life. And that was something that moved me deeply

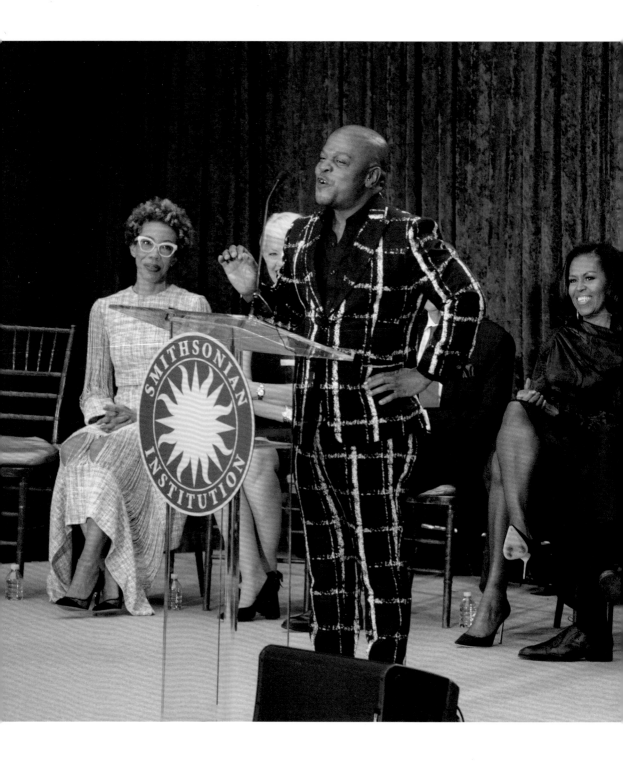

because in my small way that's part of what I believe politics should be about—not simply celebrating the high and mighty, and expecting that the country unfolds from the top down, but rather that it comes from the bottom up. From families all across America who are working hard and doing their best and passing on the wisdom, resilience, and stories to their children in the hopes that their lives will be a little bit better.

And so, I was extraordinarily excited about working with Kehinde, and let's face it, Kehinde—relative to Amy—was working at a disadvantage because his subject was less becoming. Not as fly. Michelle always used to joke that I'm not somebody who is a great subject. I don't like posing; I get impatient; I look at my watch; I think, this must be done; one of those pictures must have worked, why is this taking so long? So, it's pretty tortuous trying to just take a picture of me, much less paint a portrait. I will say that working with Kehinde was a great joy. And he and his team made it easy. Kehinde, in the tradition of a lot of great artists, actually cared to hear how I thought about it, before doing exactly what he intended to do.

I mean, there were a number of issues that we were trying to negotiate. I tried to negotiate less gray hair. And Kehinde's artistic integrity would not allow him to do what I asked. I tried to negotiate smaller ears. Struck out on that as well. Maybe the one area where there were some concessions was, as I said before, Kehinde's art often takes ordinary people and elevates them, lifts them up, and puts them in these

fairly elaborate settings. And so his initial impulse in the work was to also elevate me and put me in these settings with partridges and scepters and thrones and shift robes and mounting me on horses. And I had to explain that I've got enough political problems without you making me look like Napoleon. We've gotta bring it down just a touch.

And that's what he did. But, you know it's hard to obviously judge something that is a portrait of you. But, what I can say unequivocally is that I am in awe of Kehinde's gifts and what he and Amy have given to this country and to the world, and we are both very grateful to have been the subject of their attention for this brief moment. So, Mr. Kehinde Wiley.

KEHINDE WILEY: Yeah. So how do you explain that a lot of that is just simply not true? What is true is that this is an insane situation. To be able to stand on this stage and to look out at this crowd and to have this level of adrenaline flowing through my blood tells me that something special is going on. My whole life is driven by chance. Much of the work that I'm known for is just chance-driven, complete strangers in the streets. Trying to find people that have a sense of grace, some sort of *je ne sais quoi*, something that you feel will translate in a painting, on a museum wall. It's something that you know when you see it, you don't quite know what it is. And people are minding their own business, often trying to get to work, and I'll tap them on the shoulder and I'll say: do you mind if I paint you? Most people say no.

It's tough in the streets to get people to recognize what the import or the gravity of art is. My job has been to slowly take these moments of chance and to try to weave them into something that means something in the language of art history. These big museums, like this, are dedicated to what we as a society hold most dear. Great curators, their jobs are to be the guardians of culture, to say this is what we as a people stand for. Growing up as a kid in South Central Los Angeles, going to the museums in LA, there weren't too many people who happened to look like me in those museums, on those walls. So, as the years go on and as I try to create my own type of work, it has to do with correcting for some of that. Trying to find places where people who happen to look like me do feel accepted or do have the ability to express their state of grace on the grand narrative scale of museum space.

Well that sense, and that obsession with chance, has gotten me here. And a very strange chance since you, Mr. President, have found something in what I do. What my purpose has been as a creator, as a thinker, as a painter. To be able to project out into the world this urge, this itch, this desire to see something corrected—it seems silly, it's colored paste, it's a hairy stick, you're nudging things into being. But it's not. This is consequential, this is who we as a society decide to celebrate. This is our humanity, this is our ability to say: I matter. I was here. The ability to be the first African American painter to paint the first African American President of the United States is absolutely overwhelming.

It doesn't get any better than that. I was humbled by this invitation, but I was also inspired by Barack Obama's personal story. He and I both do have that echo of single parents, African fathers, that search for the father, that sense of twinning. There is kind of like this echo of him and me in that narrative. When you look at this painting, there's—sure—an amazingly handsome man, seated in the fore. But there are also botanicals that are going on there that nod toward his personal story. There is the chrysanthemum, which is a sort of official flower of Chicago, Illinois. There are flowers that point toward Kenya, and there are flowers that point toward Hawaiʻi. In a very symbolic way, what I'm doing is charting his path on Earth through those plants that weave their way. There is a fight going on between him and the foreground and with the plants that are sort of trying to announce themselves underneath his feet. Who gets to be the star of the show? The story, or the man who inhabits that story?

It's all chance driven. And Mr. President, I thank you for giving me a chance, and I thank you for giving this nation a chance to experience your splendor on a global scale. Thank you.

Oh, oh, oh, oh, oh, I'm so sorry.

I was so in this zone and—talk about not recognizing the real source of the light. My mother, Freddie Mae Wiley, can you please stand? There is nothing I can say. This is really where it all starts, and we didn't have much, but she found a way to get paint, and

just the ability to—[begins crying] oh, shut up and breathe!—the ability to be able to picture something bigger than that piece of South Central LA that we were living in. You saw it, you did it. Thank you.

SAJET: Congress founded the National Portrait Gallery to collect and display the portraits of those who have made a significant contribution to America's history and culture. This year marks our fiftieth anniversary, and as Secretary Skorton mentioned today, February the twelfth marks President Lincoln's 209th birthday. I want to thank all the Smithsonian, and especially the National Portrait Gallery's staff, for making today so special, with particular appreciation to our chief curator, Brandon Brame Fortune, and curators Taína Caragol and Dorothy Moss, who stewarded both commissions. I sincerely hope that all of you here today will agree that the Portrait Gallery has an extraordinary mission to visualize the motto on the great seal of America, "E pluribus unum," "out of many, one." We hope that you continue to support our work.

So, in closing, I want to leave you with some of President Lincoln's words, to remind us that what we do in life, no matter who we are, counts. "Every effect," said the president, "must have its cause . . . The past is the cause of the present, and the present will be the cause of the future. All these are links in the endless chain, stretching from the finite to the infinite." Thank you and thank you for being with us this morning.

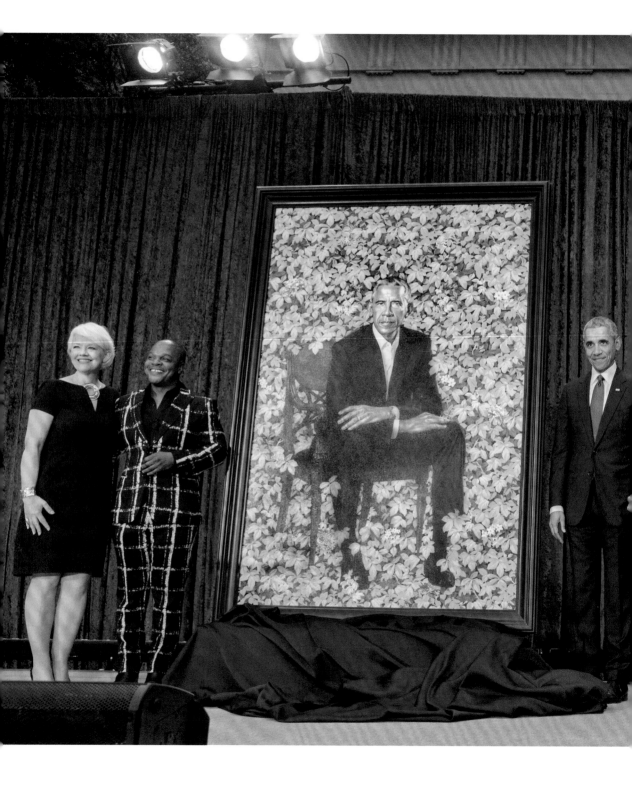

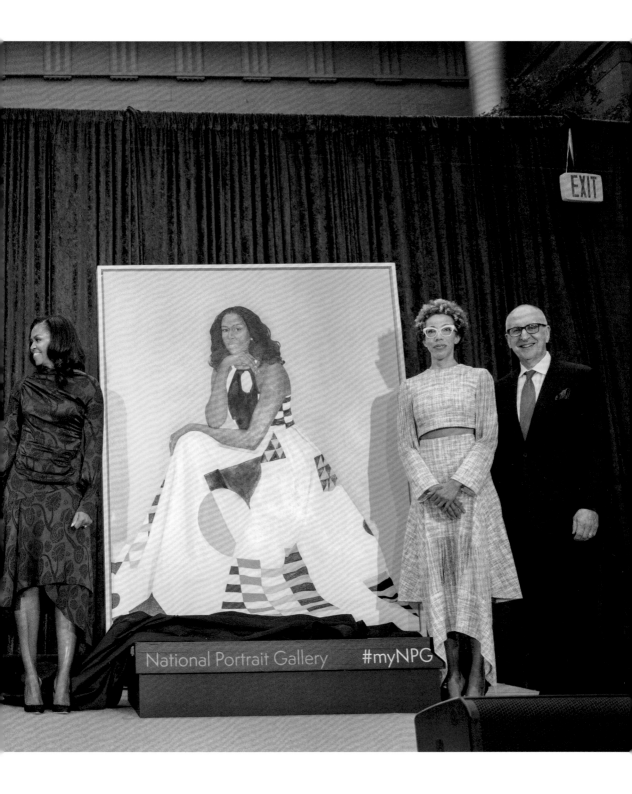

Notes

Unveiling the Unconventional: Kehinde Wiley's Portrait of Barack Obama

1. National Portrait Gallery internal communications update, compiled by Ellie Skochdopole, Communications Department, email to all staff on February 26, 2018.

2. Shortly after the unveiling, the museum welcomed 50,000 visitors over Presidents' Day weekend (Feb. 17-19, 2018), a 311 percent increase from 2017's Presidents' Day weekend.

3. For a report on the blockbuster effect of Wiley's portrait of President Obama, see Sarah Cascone, "Kehinde Wiley and Amy Sherald's Blockbuster Obama Paintings Nearly Doubled the National Portrait Gallery's Attendance in 2018," *artnet News*, October 4, 2018.

4. For a brief history on the tradition of official presidential portraits in the collection of the White House, see Lydia Tederick, "How Portraits of US Presidents and First Ladies Are Chosen," The Obama White House Archives. Overall, the oil-on-canvas paintings share an emphasis on a realist likeness, with varying inflections focusing on respectability, character, beauty, and elegance.

5. While the official painted portrait of President Barack Obama was being commissioned, the museum represented the 44th president with a pair of Woodburytypes (a photographic reproduction process), by artist Chuck Close. Even though the exhibition label text explained that Obama's official oil-on-canvas portrait was underway, many visitors complained (through visitor comment cards) that the temporary representation of Obama through this photo-based representation was not dignified enough. This attests to the importance that our audiences attribute to the medium of oil on canvas for representing a president.

6. Our collection of presidential portraits in all media, including the museum's study collection, comprises over 16,000 objects. Our current display highlights six presidents whose mandates constituted historical turning points. They are George Washington, Andrew Jackson, Abraham Lincoln, Theodore Roosevelt, Franklin D. Roosevelt, and Ronald Reagan.

7. David Ward, "America's Presidents," in *America's Presidents,* ed. David C. Ward (Washington, DC: Smithsonian Books, in association with the National Portrait Gallery, 2018), 12.

8. The first presidential portrait commissioned by the National Portrait Gallery was the portrait of President George H. W. Bush by Ronald Sherr (1994-95). The first portrait of a first lady to be commissioned by the National Portrait Gallery was Ginny Stanford's portrait of Hillary Rodham Clinton (2006).

9. Kelly Crow, "Obamas Choose Rising Stars to Paint Their Official Portraits," *Wall Street Journal,* October 13, 2017.

10. The Obamas chose the artworks for the White House in consultation with their interior decorator, Michael S. Smith, and the White House curator, William "Bill" G. Allman. Their choices were widely covered by the media in 2009 and again in 2017. See Carol Vogel, "Obamas Spruce Up White House with Borrowed Art," *New York Times,* October 6, 2009; and Nancy Benac, "Obamas Decorate White House with Modern and Abstract Works of Art," *Art Daily,* October 7, 2009.

11. The fact that the Obamas understand the roles of curator and art expert was made clear in Michelle Obama's acknowledgments at the unveiling ceremony, when she said, "I want to thank Bill Allman, Thelma Golden, Michael Smith . . . who guided us every step of the way . . . We never could have done this without you, because you not only know your craft and all these folks, but you know us intimately; you knew what we were looking for and what we wanted to say." See "The Presentation of the Obama Portraits: A Transcript of the Unveiling Ceremony," p. 108.

12. According to Michael Smith, the Obamas parted with convention in 2009 by not just borrowing one or two artworks from museums to decorate the White House, but dozens. He added that it was unprecedented and "a big thing to be so inclusive, to bring in women artists, LGBT artists, African-American artists." See David Crow, "Michael S. Smith: Obama's White House Designer on His New York Penthouse," *Financial Times*, August 17, 2018.

13. From the time of his campaign, Barack Obama's team was praised for its thoughtful craft of his public image and brand. As journalists and political and marketing experts have analyzed, Obama's campaign galvanized marketing tactics and image branding, and their promotion through new social media platforms cemented the image of Obama as a new kind of global leader who was genuine, transparent, fresh, optimistic, and ready to break with past broken political models. This public image aimed to attract the new millennial voting demographic and also bridged the racial divide that could have tampered Obama's political aspirations as the first African American presidential candidate. When he won the presidency, that care for a flawless image extended to his wife, Michelle, and to a lesser extent their daughters, whom they tried to keep out of the limelight as much as possible. See Staci M. Zavattaro, "Brand Obama: The Implications of a Branded President," in *Administrative Theory & Praxis* 32, no. 1 (2010): 123–28; Ellen McGirt, "The Brand Called Obama," *Fast Company Compass*, April 1, 2008; Doreen St. Félix, "Michelle Obama's New Reign of Soft Power," *New Yorker*, December 6, 2018.

14. Some examples of this effort include the exhibitions *The Sweat of Their Face: Portraying American Workers* (2017) and *UnSeen: Our Past in a New Light: Ken Gonzales-Day and Titus Kaphar* (2018). The former probed the invisibility of workers while the latter reexamined historical portraits of indigenous people and enslaved African Americans and their descendants. Beyond its exhibition program, the National Portrait Gallery has commissioned James Luna, Wilmer Wilson, Maria Magdalena Campos-Pons, Sheldon Scott, and other contemporary artists for its series *IDENTIFY: Performance Art as Portraiture*, which explores aspects of American history that historically have not been represented at the National Portrait Gallery.

15. The breakthrough that led Wiley to focus his early work on depicting African American men came in 2002, when he was an artist in residence at the Studio Museum in Harlem. During that time, he found on the street a sheet of paper with the mugshot of a young African American searched for robbery. The contrast between the man's sympathetic demeanor and his identifying information, including his small crimes, steered Wiley into an artistic practice that would give African American men the power they have historically been denied in society. See "(1) 'Kehinde Wiley: A New Republic' Video Series," Virginia Museum of Fine Arts, April 16, 2018, https://www.youtube.com/watch?v=gx6rGZ4dx2E.

16. See video interview in Robin Pogrebin, "Obama Portrait Artists Merged the Everyday and the Extraordinary," *New York Times*, February 12, 2018.

17. Ibid.

18. The symbolism of the flowers was conveyed in an email from Amy Gadola, Kehinde Wiley's studio manager, to the museum's chief curator, Brandon Brame Fortune, on January 16, 2018.

19. For a discussion of the chair, see p. 70 in this volume. Also see "There Is No Obama Chair," *greg.org: the making of, by greg allen*, February 18, 2018; and Michele Hansen, "About the Chair in President Obama's Portrait," *Medium*, February 19, 2018.

20. Early in 2008, street artist Shepard Fairey was inspired by the values of presidential candidate Barack Obama, and he sought permission from the Obama campaign to independently create a poster in support of the candidate. The resulting artwork was a stylized stencil of Obama's face in a blue, red, and white color scheme, with the captions "PROGRESS" and "HOPE" written below. Eventually, the Obama campaign asked him to use only the word HOPE. Fairey printed a first run of 700 posters, most of which were given to the public at no cost. Several thousand more were printed for Super Tuesday. After Fairey posted the image to his website, it went viral, spreading by social media and word of mouth. Over 350,000 posters were printed and more than 500,000 stickers were produced. The image was also reproduced on t-shirts and public murals. Obama's brand was so strong that an

artist without any official command produced an image that embodied it to perfection. See "Now on View: Portrait of Barack Obama by Shepard Fairey" *Face to Face: A Blog from the National Portrait Gallery,* and Mac Scott, "Obama Hope Poster—Shepard Fairey (2008)," *Medium*, October 15, 2017. Also see Randy Kennedy, "Obama Image Copyright Case Is Settled," *New York Times*, January 12, 2011, for insight into the case brought against Fairey by A.P. and photographer Mannie Garcia. I am grateful to Wendy Wick Reaves, the museum's curator emerita for prints and drawings, for her insight into the Shepard Fairey portrait, which she helped acquire.

"Radical Empathy": Amy Sherald's Portrait of Michelle Obama

1. "The Presentation of the Obama Portraits: A Transcript of the Unveiling Ceremony," February 12, 2018, p. 108. For full transcript, see pp. 98–127.

2. Teju Cole, "There's Less to Portraits than Meets the Eye and More," *New York Times Magazine*, August 23, 2018.

3. Krystal Mack quoted in Liz Calka, "A Baker's 250-Square-Foot Studio Celebrates Art, Women, and Creativity," *ApartmentTherapy.com*, July 17, 2018.

4. Helen Molesworth, email message to Dorothy Moss, Jerry Saltz, Dawoud Bey, and John Valadez, September 5, 2015.

5. "The Presentation of the Obama Portraits: A Transcript of the Unveiling Ceremony," February 12, 2018, p. 110.

6. Sherald's father, Amos P. Sherald III, had died a decade earlier.

7. Doreen St. Félix, "The Mystery of Amy Sherald's Portrait of Michelle Obama," *New Yorker*, February 13, 2018.

8. "The Presentation of the Obama Portraits: A Transcript of the Unveiling Ceremony," February 12, 2018, p. 108.

9. Ibid, pp. 108–10.

10. Ibid, p. 111.

11. Michelle Obama, *Becoming* (New York: Crown, 2018), 419.

12. "The Presentation of the Obama Portraits: A Transcript of the Unveiling Ceremony," February 12, 2018, p. 115.

13. Alex Ronan, "The Master Quilters of Gee's Bend: Stitching Together Questions of Race, Art, and Commerce through a Quilting Tradition Borne in Slavery," *The Outline*, October 16, 2018.

14. "Amy Sherald in Conversation with Osman Can Yerebakan," *The Brooklyn Rail*, October 2019, brooklynrail.org.

15. Recent visitors include the high school students from Parkland, who led the march and later returned to the National Portrait Gallery to participate in a dialogue with DC public school students about how to lead and participate in the youth movement against gun violence.

16. Doreen St. Félix, "The Mystery of Amy Sherald's Portrait of Michelle Obama," *New Yorker*, February 13, 2018.

17. Artist's statement by Wanda Raimundi-Ortiz.

18. Leah Sandler, " 'Pieta,' A Performance by Wanda Raimundi-Ortiz Creates a Space for Radical Empathy," *Orlando Weekly*, March 15, 2017.

19. "The Presentation of the Obama Portraits: A Transcript of the Unveiling Ceremony," February 12, 2018, pp. 106–8.

The Obama Portraits, in Art History and Beyond

1. A portrait sculpture rather than a painting, Lei Yixin's 2011 granite statue of the Reverend Dr. Martin Luther King Jr. (in connection with the King Memorial on the National Mall in Washington, DC) has been the object of considerable censure, much of the criticisms of a contextual nature similar to what many painted portraits receive. See Michael J. Lewis, "Monumental Failures," *USA Today,* September 2012, 50–53; and Victor Margolin, "The Martin Luther King Jr. Memorial: A Flawed Concept," *Journal of Visual Culture* 11, no. 3 (2012): 400–408.

2. The "grand manner" is described by curator Michael Quick as "elevated, heightened, formal portraiture." Michael Quick, "Princely Images in the Wilderness: 1720-1775," in Michael Quick, Marvin Sadik, and William H. Gerdts, *American Portraiture in the Grand Manner, 1720-1920* (Los Angeles: Los Angeles County Museum of Art, 1981), 11. Also see: Norman Rosenthal, *Citizens and Kings: Portraits in the Age of Revolution, 1760-1830* (London: Royal Academy of Arts, 2007).

3. Elaine Kilmurray and Richard Ormond, eds., *John Singer Sargent* (Princeton: Princeton University Press, 1998); and Frederick S. Voss, *Portraits of the Presidents: The National Portrait Gallery* (New York: Rizzoli, 2012).

4. This essay springs from some preliminary thoughts about these two portraits that I offered during an interview with *Slate* just after their February 2018 unveiling: Rachelle Hampton, "Why the Obamas' New Paintings Are a Milestone in Black Portraiture," *Slate,* February 12, 2018.

5. Photography historian and visual theorist Jasmine Nichole Cobb traces the art historical lineage of the black figures in the 1834 Zuber & Cie wallpaper, along with deconstructing their historical and contemporary significance, in: Jasmine Nichole Cobb, "Racing the Transat-lantic Parlor: Blackness at Home and Abroad," in *Picturing Freedom: Remaking Black Visuality in the Early Nineteenth Century* (*America and the Long 19th Century* series) (New York: New York University Press, 2015), 193-220.

6. William Grimes, "Aaron Shikler, Portrait Artist Known for Images of America's Elite, Dies at 93," *New York Times,* November 16, 2015.

7. Charlotte Mullins, *Picturing People: The New State of the Art* (London: Thames & Hudson, 2015).

8. Barkley L. Hendricks, Kehinde Wiley, and other portraitists of peoples of African descent are discussed at length in: Richard J. Powell, *Cutting a Figure: Fashioning Black Portraiture* (Chicago: University of Chicago Press, 2008).

9. "Sherald creates otherworldly portraits of everyday black folk that operate somewhere between a weighted past and an obtainable future," writes curator and arts programmer Erin Christovale. Erin Christovale, "Notes on Amy Sherald," in *Amy Sherald* (St. Louis: Contemporary Art Museum St. Louis, 2019), 13.

10. A textbook case of the widely divergent expectations between a portraitist and a sitter (or a portrait commissioner), sculptor Robert Arneson's controversial 1981 commemorative portrait of the slain San Francisco mayor George Moscone is discussed in: Robert Atkins, "Going Home," *Art in America* 101, no. 5 (May 2013): 57-60.

11. Trevor Schoonmaker, ed., *Barkley L. Hendricks: Birth of the Cool* (Durham, NC: Nasher Museum of Art at Duke University, 2008).

12. Brooke Bobb, "Michelle Obama Wears Milly in Her Official Portrait—Here's the Story Behind the Dress," *Vogue,* February 13, 2018.

13. Souleymane Cissé, "Seydou reconnaissait le visage de chacun des ses clients," in *Seydou Keïta* (Paris: Réunion des musées nationaux-Grand Palais, 2016), 8-10.

14. Sarah Betzer, "Ingres's Second *Madame Moitessier:* 'Le Brevet du Peintre d'Histoire,'" *Art History* 23, no. 5 (December 2000): 681-705.

15. Ralph Ellison, *Invisible Man* (1952; New York: Vintage Books Edition, 1972), 430-31.

16. Linda Nochlin, "Women, Art, and Power," in Norman Bryson, Michael Ann Holly, and Keith Moxey, eds., *Visual Theory: Painting and Interpretation* (Cambridge: Polity Press, 1991), 40. Also see: Griselda Pollock, *Vision and Difference: Femininity, Feminism, and the Histories of Art* (London: Routledge, 1988).

17. Stephanie D'Alessandro and Luis Pérez-Oramas, *Tarsila do Amaral: Inventing Modern Art in Brazil* (Chicago: Art Institute of Chicago, 2017).

18. Two books in which a representative group of black women's images in painting, sculpture, and graphic art fill the recognition vacuum are: Gwendolyn DuBois Shaw, *Portraits of a People: Picturing African*

Americans in the Nineteenth Century (Andover, MA: Addison Gallery of American Art, 2006); and David Bindman and Henry Louis Gates Jr., eds., *The Image of the Black in Western Art. Volume V, Part 2: The Twentieth Century: The Rise of Black Artists* (Cambridge, MA: Belknap Press of Harvard University Press, 2014).

19. Michelle Obama, *Becoming* (New York: Crown, 2018).

20. Kathleen Thompson and Hilary Mac Austin, eds., *The Face of Our Past: Images of Black Women from Colonial America to the Present* (Bloomington: Indiana University Press, 1999); Deborah Willis and Carla Williams, *The Black Female Body: A Photographic History* (Philadelphia: Temple University Press, 2002); and Deborah Wills, *Reflections in Black: A History of Black Photographers 1840 to the Present* (New York: W. W. Norton, 2000).

21. "Sale 2441/Lot 75: (Slavery and Abolition.) Photography. Civil War-period carte-de-visite album, including two photographs of Harriet Tubman, one of them unrecorded," *Swann Auction Galleries, Printed & Manuscript African Americana,* March 30, 2017.

22. Craig D. Lindsey, "Everyone Keeps Comparing *Empire* to *King Lear,* but *The Lion in Winter* Is Its True Predecessor," *Vulture,* January 14, 2015; Krista Thompson, "The Sound of Light: Reflections on Art History in the Visual Culture of Hip-Hop," *The Art Bulletin* 91, no. 4 (December 2009): 481–505; "Kehinde Wiley: Portraits with Power," *Scholastic Art* 43, no. 6 (April/May 2013): 4–7; LL Cool J, "Kehinde Wiley: Iconoclast," *Time,* April 19, 2018; Lauren Collins, "Lost and Found," *New Yorker* 84, no. 26 (September 1, 2008): 56, 58; Kimberly Straub, "Kehinde Wiley," *Vogue,* September 2, 2009; and Thelma Golden, "Kehinde Wiley: The Painter Who Is Doing for Hiphop Culture What Artists Once Did for the Aristocracy," *Interview* 35, no. 9 (October 2005): 158–63.

23. Eugenie Tsai, ed., *Kehinde Wiley: A New Republic* (New York: Brooklyn Museum, 2015).

24. In addition to the research that immediately followed the National Portrait Gallery's invitation, Kehinde Wiley, who received an MFA degree (2001) from the Yale School

of Art, would have been familiar with the Yale University Art Gallery's most famous presidential portraits: Charles Willson Peale's *George Washington at the Battle of Princeton* (1781) and John Trumbull's *General George Washington at Trenton* (1792). These paintings, along with his childhood exposure to the "grand manner" portraits of Joshua Reynolds and Thomas Gainsborough at the Huntington Library in San Marino, California, all provided important source material and inspiration for what Wiley would eventually create as a professional artist. Christine Y. Kim, "Faux Real: Interview with Kehinde Wiley," in *Black Romantic: The Figurative Impulse in Contemporary African-American Art* (New York: Studio Museum in Harlem, 2002), 48–54.

25. *A Souvenir of the Exhibition Entitled Healy's Sitters; or, A Portrait Panorama of the Victorian Age, Being a Comprehensive Collection of the Likenesses of Some of the Most Important Personages of Europe and America, as Portrayed by George Peter Alexander Healy Between the Years 1837 and 1899, Supplemented with Documents Related to the Artist's Life and Furnishings of the Period, on view at the Virginia Museum of Fine Arts in Richmond 24 January–5 March 1950* (Richmond: Virginia Museum of Fine Arts, 1950), 56–57.

26. "(Lunch) (Mr. & Mrs. Douglas Chandor) 1:00 PM," President Franklin Delano Roosevelt's Stenographer's Diary, March 19, 1945. Roosevelt died on April 12, 1945.

27. John Bulwer, *Chirologia: or The Naturall Language of the Hand. Composed of the Speaking Motions, and Discoursing Gestures Thereof. Whereunto Is Added Chironomia: or, The Art of Manuall Rhetoricke. Consisting of the Naturall Expressions, Digested by Art in the Hand, as the Chiefest Instrument of Eloquence* (London: Thomas Harper, 1644).

28. Ellen G. Miles, "Rubens Peale with a Geranium," in Robert Wilson Torchia, Deborah Chotner and Ellen G. Miles, *American Painting of the Nineteenth Century, Part II. The Collections of the National Gallery of Art Systematic Catalogue* (Washington, DC: National Gallery of Art, 1998), 48–57.

29. "The Presentation of the Obama Portraits: A Transcript of the Unveiling Ceremony,"

February 12, 2018, p. 125. For full transcript, see pp. 98-127.

30. Andrea Wolk Rager, "'Smite This Sleeping World Awake': Edward Burne-Jones and The Legend of the Briar Rose," *Victorian Studies* 51, no. 3 (Spring 2009): 438-50.

31. Gilane Tawadros, "Objects of Desire," in *Sonia Boyce: Speaking in Tongues* (London: Kala Press, 1997), 7-27.

32. Shirley Lau Wong, "The World and the Garden: Ekphrasis and 'Overterritorialization' in Jamaica Kincaid's Garden Writing," *Cambridge Journal of Postcolonial Literary Inquiry* 5, no. 1 (January 2018): 39.

33. Judith E. Stein, *I Tell My Heart: The Art of Horace Pippin* (Philadelphia: Pennsylvania Academy of the Fine Arts, 1993).

34. When artists stopped seeing the "signified" and the "signifier" as reconcilable agents, writes literary theorist Ernst van Alphen, "the portrait loses its exemplary status for mimetic representation." "Artists who have made it their project to challenge the originality and homogeneity of human subjectivity or the authority of mimetic representation, often choose the portrait as the genre to make their point," van Alphen continues, predictively describing Kehinde Wiley's and Amy Sherald's re-conceptions of the genre as applied to the portraits of the president and first lady. Ernst van Alphen, "The Portrait's Dispersal: Concepts of Representation and Subjectivity in Contemporary Portraiture," in Joanna Woodall, ed., *Portraiture: Facing the Subject* (Manchester: Manchester University Press, 1997), 242.

The Obama Portraits and the National Portrait Gallery as a Site of Secular Pilgrimage

1. At the end of the 2018 fiscal year, the museum had welcomed a record 2.1 million visitors, approximately twice as many as it had in previous years.

2. Victor Witter Turner and Edith L. B. Turner, *Image and Pilgrimage in Christian Culture: Anthropological Perspectives (Lectures on the History of Religions)* (New York: Columbia University Press, 1978), 1-39.

3. John Eade and Michael J. Sallnow, eds., *Contesting the Sacred: The Anthropology of Christian Pilgrimage* (New York: Routledge, 1991). Also see Peter Jan Margry, "Secular Pilgrimage: A Contradiction in Terms?" in *Shrines and Pilgrimage in the Modern World: New Itineraries into the Sacred*, ed. Peter Jan Margry (Amsterdam: Amsterdam University Press, 2008), 13-46.

4. Walt Whitman, "1. Specimen Days. 27. Patent-Office Hospital," *Prose Works,* 1892.

5. For an insightful history of the Old Patent Office building, see Charles J. Robertson, *Temple of Invention: History of a National Landmark* (Washington, DC: Smithsonian American Art Museum and National Portrait Gallery; New York: Scala Publishers, 2006).

6. Carol Duncan, "Ritual in the Early Louvre Museum," in *The Cultural Politics of Nationalism and Nation-Building*, eds. Rachel Tsang and Eric Taylor Woods (New York: Routledge, 2014), 90, 87-103.

7. The congressional charter directed that the museum would be free to the public and collect, display, and study portraiture depicting the men and women who have made significant contributions to the history, development, and culture of the people of the United States.

8. N. Collins-Kreiner, "Researching Pilgrimage: Continuity and Transformations," *Annals of Tourism Research* 37, no. 2 (April 1, 2010): 440-56. See p. 445 for a discussion on the "third space," which acknowledges, both implicitly and explicitly, the interdependent nature of sites as simultaneously religious and secular.

9. This essay expands upon my article that was published on the first anniversary of the unveiling: "The Obama Portraits Have Had a Pilgrimage Effect," *theatlantic.com*, February 12, 2019.

10. "Obama: Remember the Spirit of Lincoln," *Associated Press*, February 12, 2009.

11. Roberta Smith, "Why the Obamas' Portrait Choices Matter," *New York Times*, October 16, 2017.

12. Antwaun Sargent, "Inside the Obama Portraits Unveiling: Witnessing Visions of Black Power Shake Up a Gallery of White History," *W* magazine, February 13, 2018. Also see *Visual Theory: Painting an Interpretation*, ed. Norman Bryson, Michael Ann Holly, and Keith Moxey.

13. See the introduction in Michael Eric Dyson, *The Black Presidency: Barack Obama and the Politics of Race in America* (New York and Boston: Houghton Mifflin Harcourt, 2016).

14. Emily Lordi, "Reading Michelle Obama's 'Becoming' as a Motherhood Memoir," *New Yorker*, February 5, 2019.

15. It was with some hilarity that I saw myself portrayed on an episode of *Scandal*, guiding Olivia Pope, played by Kerry Washington, through a faux National Portrait Gallery to see her picture being gazed at by two little girls.

16. On August 17, 2018, Perry C. from Baltimore, Maryland, wrote the following comment on Trip Advisor: "We visited this museum specifically to see the Obama portraits. The people lined up to see Mr. Obama's portrait immediately connected with one another, hugging each other and even weeping. It was joyful and deeply moving."

Selected Bibliography

Christovale, Erin. *Amy Sherald*. St. Louis: Contemporary Art Museum St. Louis, 2019. Exhibition catalogue.

Cotter, Holland. "Obama Portraits Blend Paint and Politics, and Fact and Fiction." *New York Times*, February 12, 2018.

Crow, Kelly. "Obamas Choose Rising Stars to Paint Their Official Portraits." *Wall Street Journal*, October 13, 2017.

Cunningham, Vinson. "The Shifting Perspective in Kehinde Wiley's Portrait of Barack Obama." *New Yorker*, February 13, 2018.

Golden, Thelma. *Kehinde Wiley*. New York: Rizzoli, 2012.

Hampton, Rachelle. "Why the Obamas' New Paintings Are a Milestone in Black Portraiture." *Slate,* February 12, 2018. https://slate.com.

Kelly, Simon, and Hannah Klemm. *Kehinde Wiley: Saint Louis*. Los Angeles: Roberts Projects (for the St. Louis Art Museum), 2019. Exhibition catalogue.

Kennicott, Philip. "The Obamas' Portraits Are Not What You'd Expect, and That's Why They're Great." *Washington Post*, February 12, 2018.

McGlone, Peggy. "'Where Are the Obamas?': Paintings of Barack and Michelle Brought a Million More People to Portrait Gallery." *Washington Post*, February 26, 2019.

Nelson, Steven. "The Obama Portraits and the History of African American Portraiture." *Hyperallergic*, March 14, 2018. https://hyperallergic.com.

Nieves, A'Driane. "Amy Sherald's Official Portrait of Michelle Obama Reimagines What It Means to Be a Vibrant, Powerful Black Woman." *Medium*, February 12, 2018. https://medium.com.

Petrovich, Dushko. "The New Face of Portrait Painting." *T (The New York Times Style Magazine)*, February 12, 2018.

Pogrebin, Robin. "After a Late Start, an Artist's Big Break: Michelle Obama's Official Portrait." *New York Times*, October 23, 2017.

———. "Obama Portrait Artists Merged the Everyday and the Extraordinary." *New York Times*, February 12, 2018.

Rosenwald, Michael S. "'A Moment of Awe': Photo of Little Girl Captivated by Michelle Obama Portrait Goes Viral." *Washington Post*, March 4, 2018.

Schjeldahl, Peter. "Beheld: Amy Sherald's Portraits." *New Yorker*, September 23, 2019, 68–69.

Shapiro, Ari. "Artist Amy Sherald Discusses Portrait of Former First Lady Michelle Obama." NPR. February 12, 2018. https://npr.org.

Smith, David. "Barack and Michelle Obama's Official Portraits Expand Beyond Usual Format." *The Guardian*, February 12, 2018. https://theguardian.com.

Smith, Roberta. "Why the Obamas' Portrait Choices Matter." *New York Times*, October 16, 2017.

"Spotlight Obama: Presidential Portraits." *International Review of African American Art* 28, no. 2 (2018): 58–64.

St. Félix, Doreen. "The Mystery of Amy Sherald's Portrait of Michelle Obama." *New Yorker*, February 13, 2018.

Tsai, Eugenie, ed. *Kehinde Wiley: A New Republic*. New York: Brooklyn Museum, 2015. Exhibition catalogue.